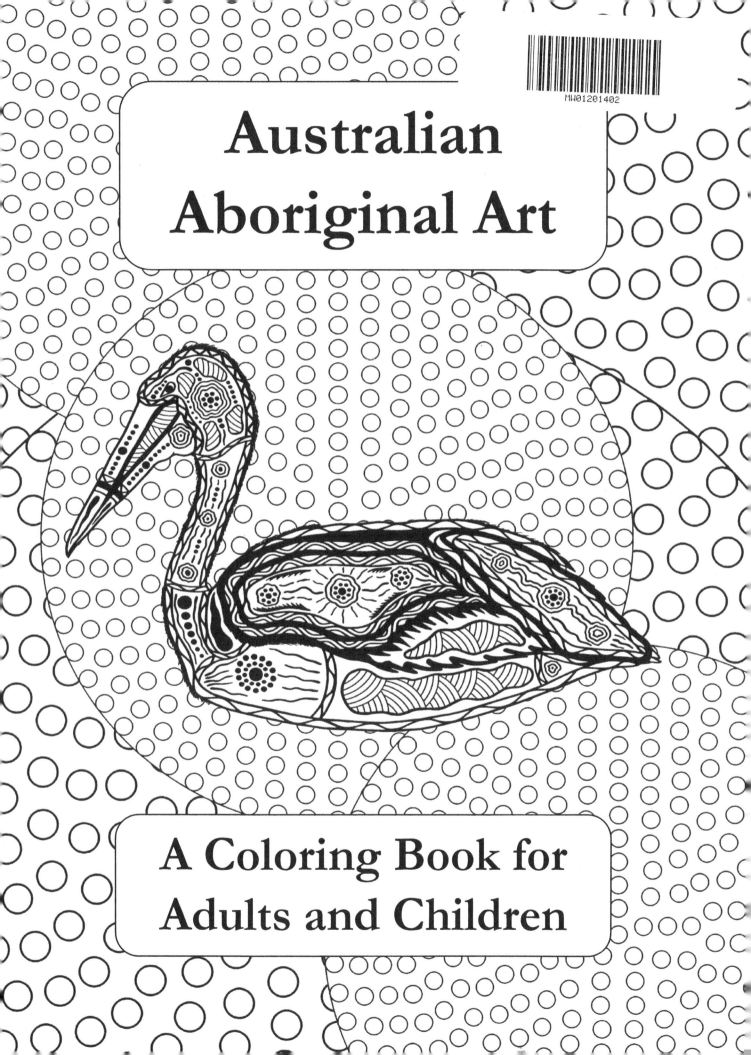

Australian Aboriginal Art

A Coloring Book for Adults and Children

INTRODUCTION

I have been given 45 drawings by an Australian indigenous artist featuring native Australian wildlife to use in a coloring book for all ages. I have used 20 for book 2 to create 70 designs on one sided pages. The size of the book is 8.5 x 11 and has 146 pages.

Most of the designs are of native Australian wildlife with a Crocodile, Turtle, Gecko, Goanna, Echidna, Bilby, Butterfly, Crow, Emu, Pelican, Crab, Lobster, Dugong and Fish.

Each design will have three variations:

- The first is the original.
- The second is the original placed on dot art.
- The third is with the animal enlarged and by itself for children to color and maybe cut out.
- The fourth is by itself and surrounded by dot art for children to color also.

Originally, I was only going to use the 45 designs for one book, but then I decided to produce a series of books for the whole family to use, where you can get the children involved in coloring the dot art designs I made.

In Australian Aboriginal dot art, they mainly use colors seen in nature like, Reds, Yellows, Browns, Greens, Blues, Black and White. These are the colors I have been using for the dot circles on the front cover, but then you can use any color you like.

At the end of the book there is a **BONUS** page where you can download the 70 designs to color as many times as you like.

I also have a Facebook page where you can look at what the artist has colored to give you an idea what colors to used, and ask me questions. I will keep adding colored designs and information on upcoming books.

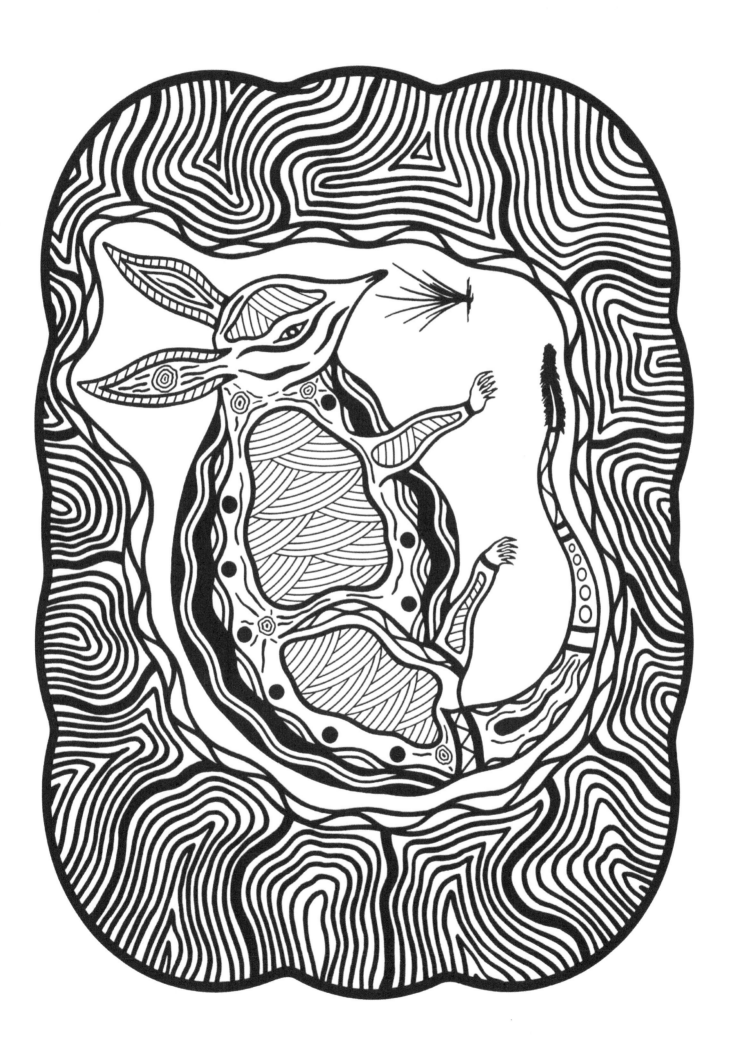

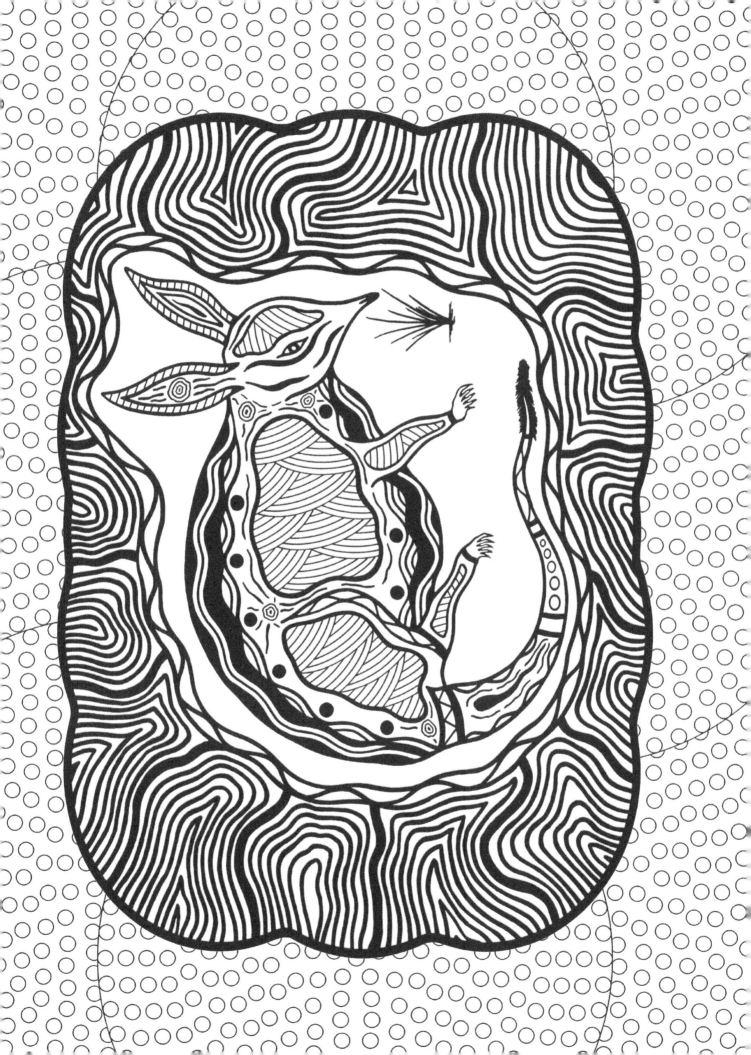

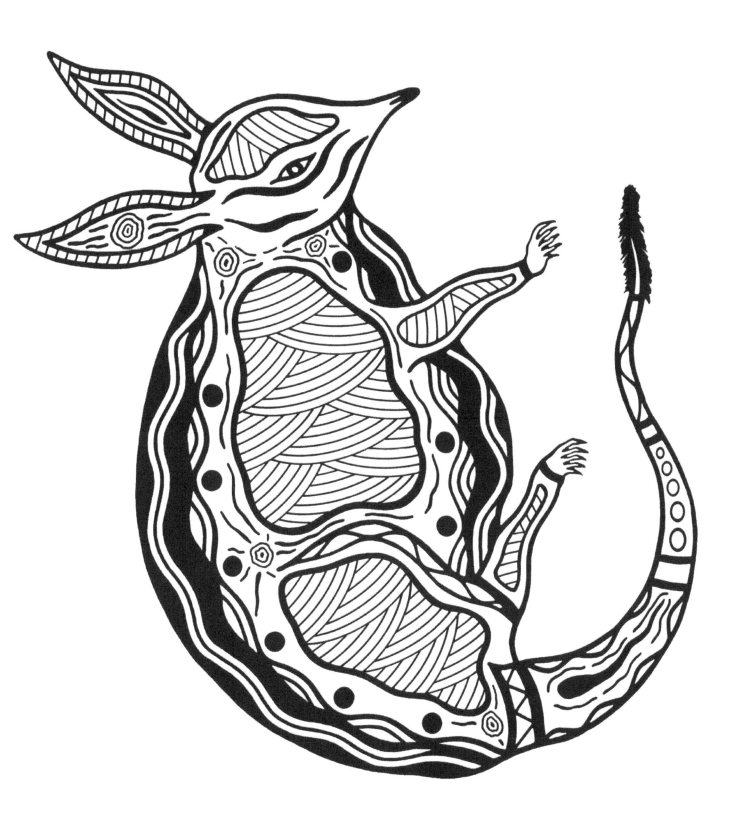

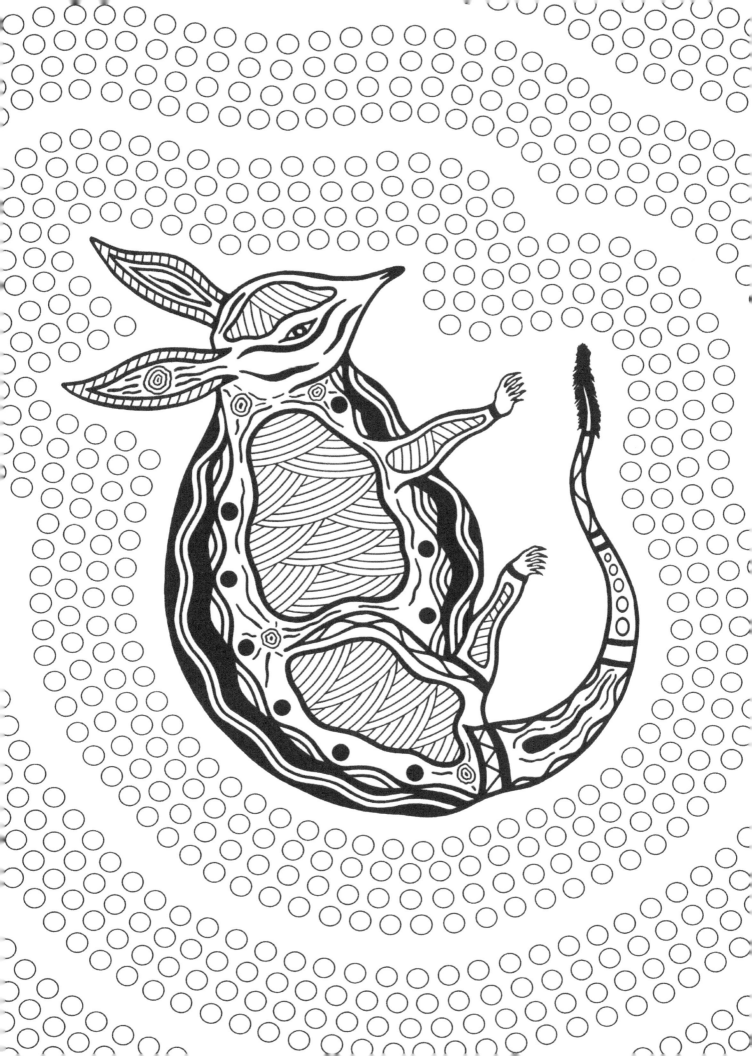

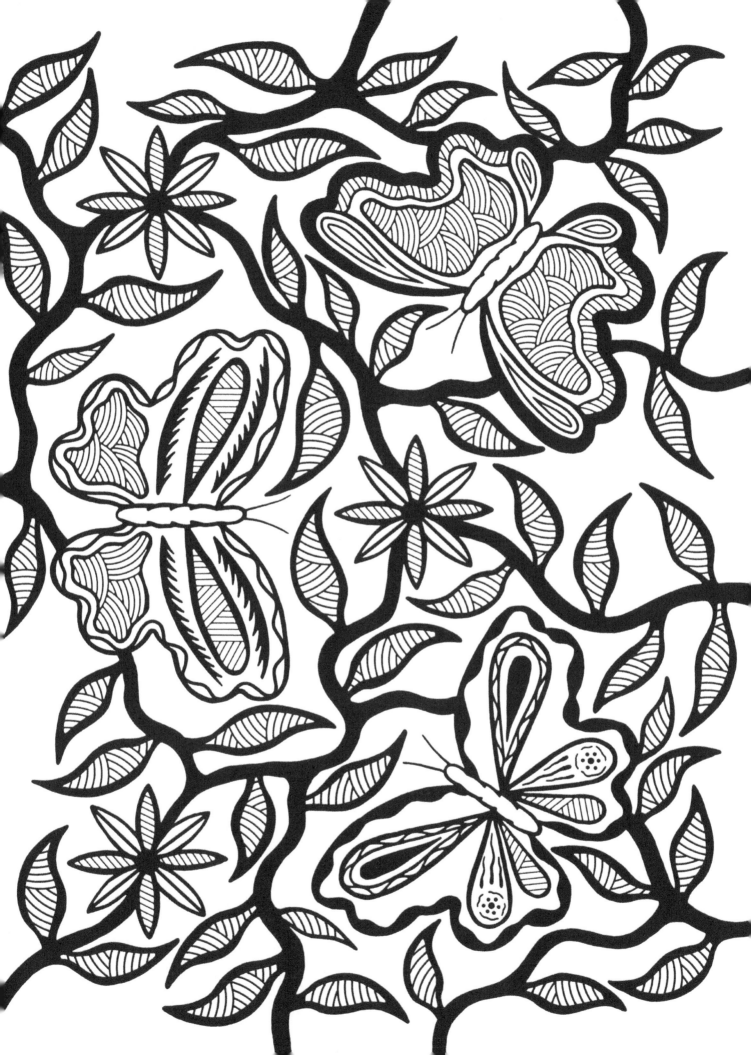

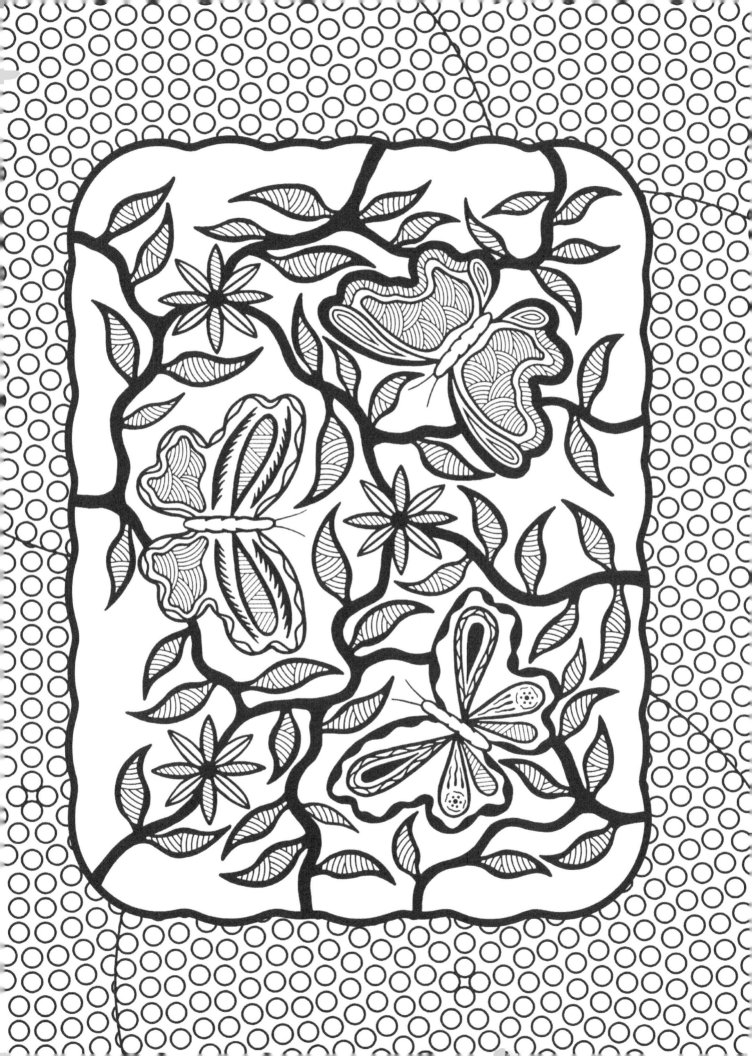

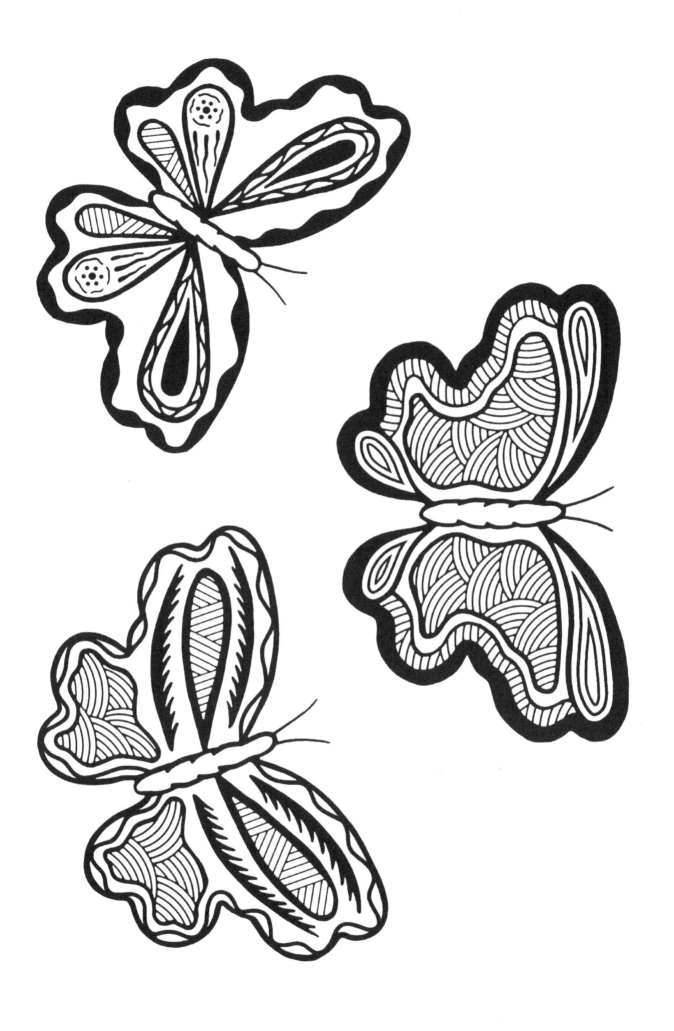

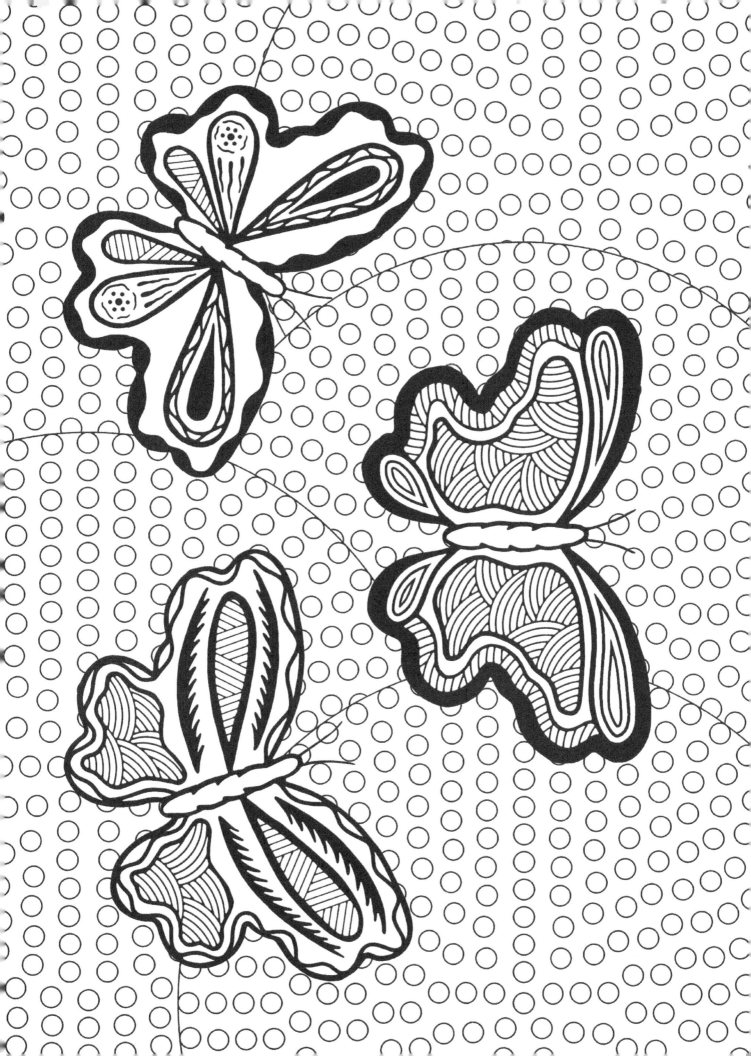

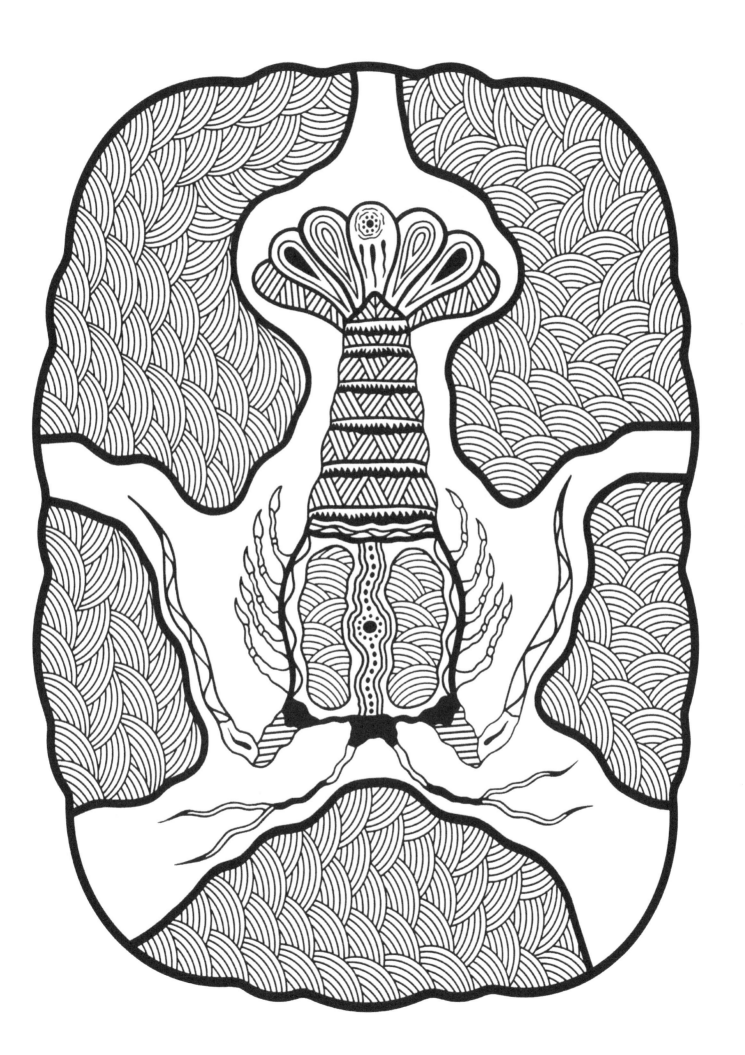

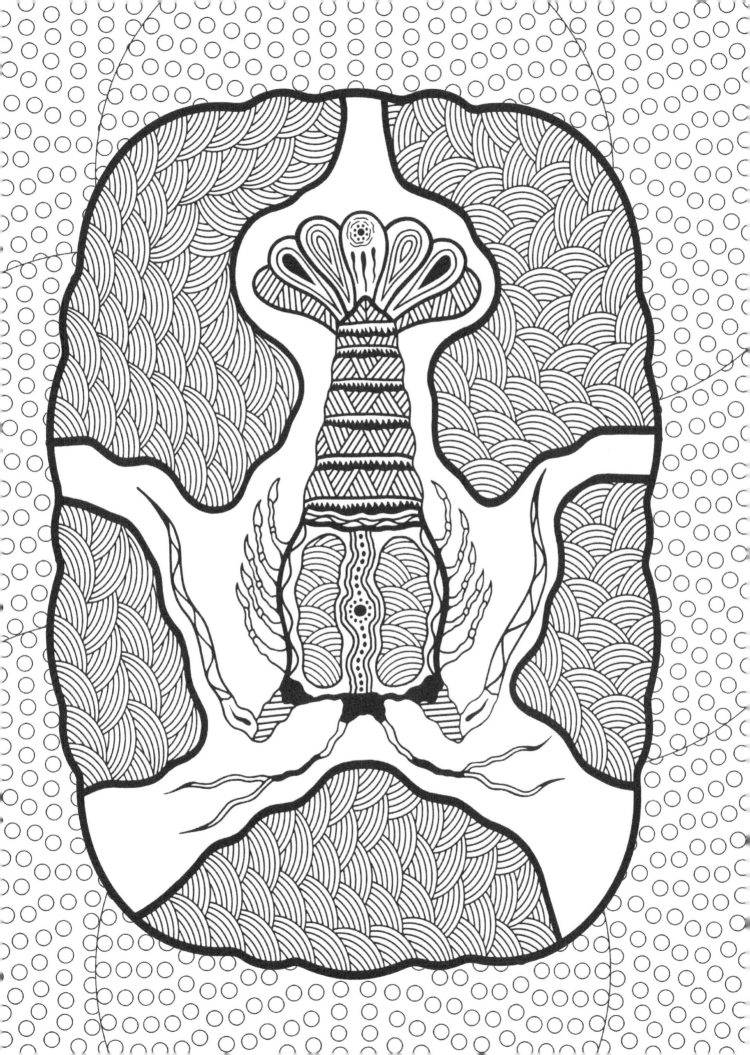

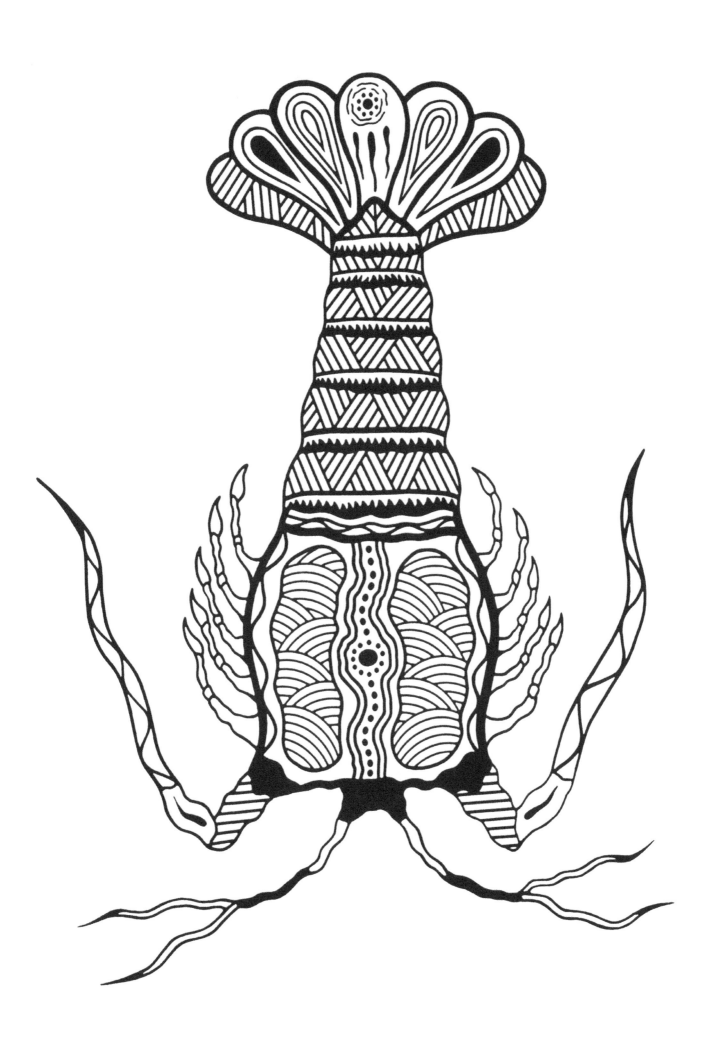

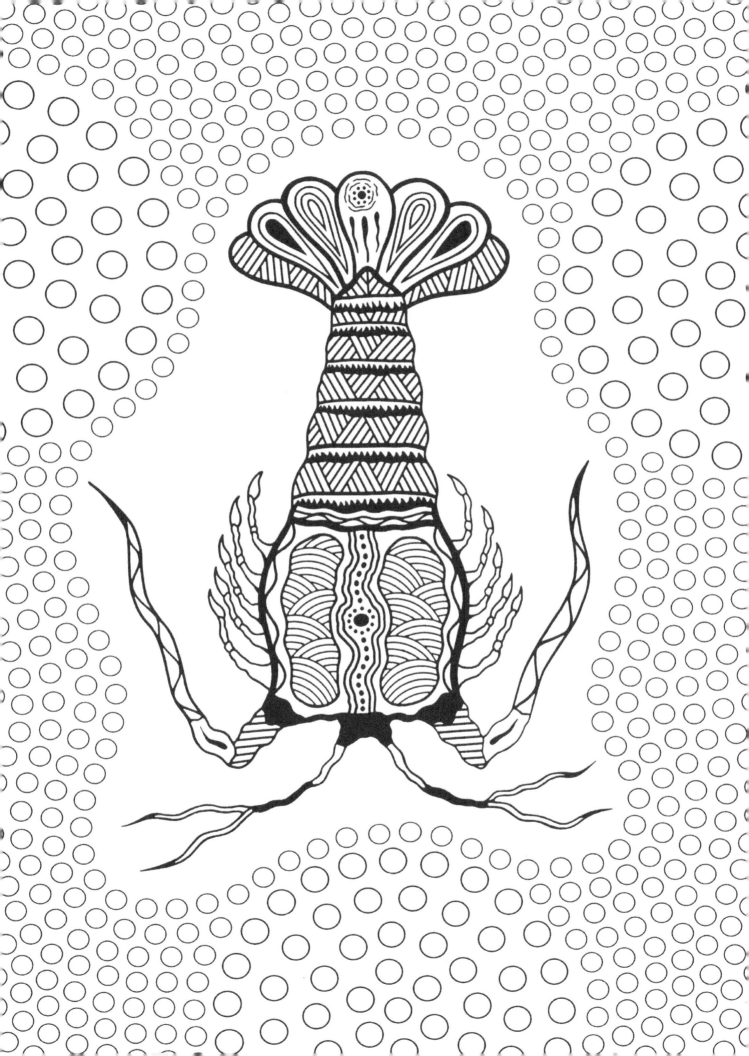

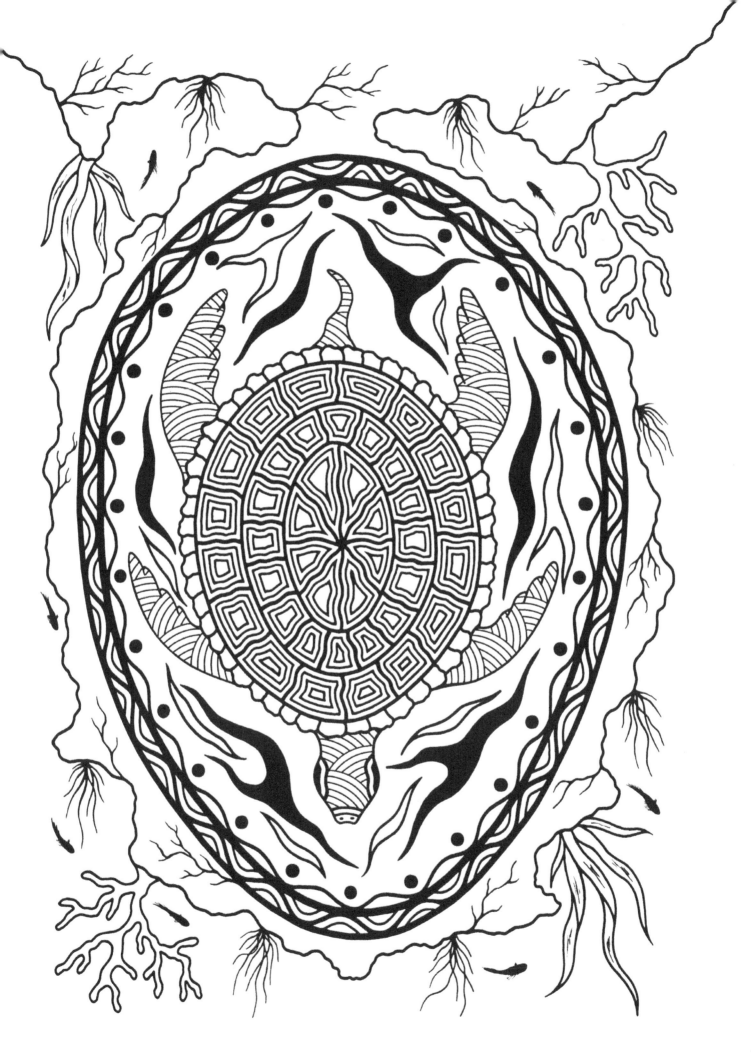

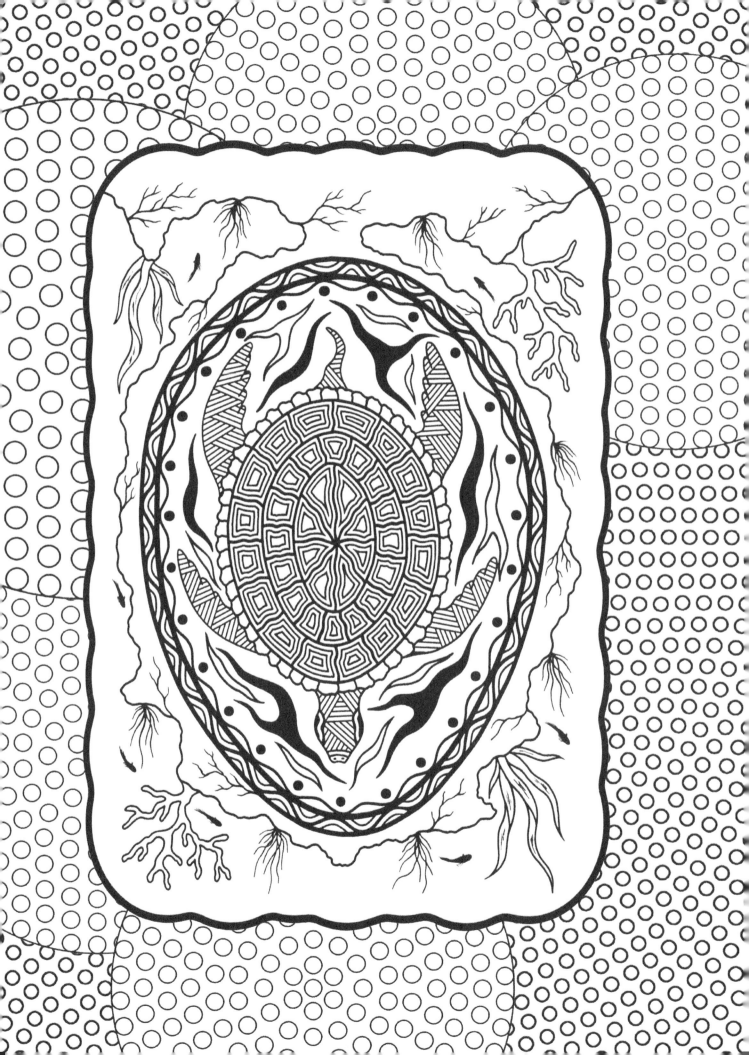

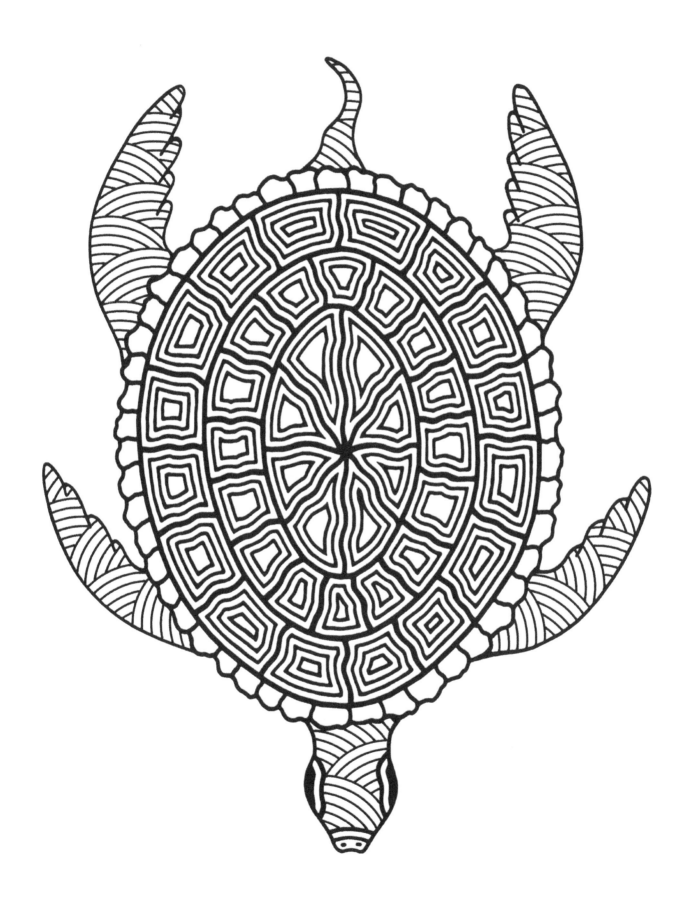

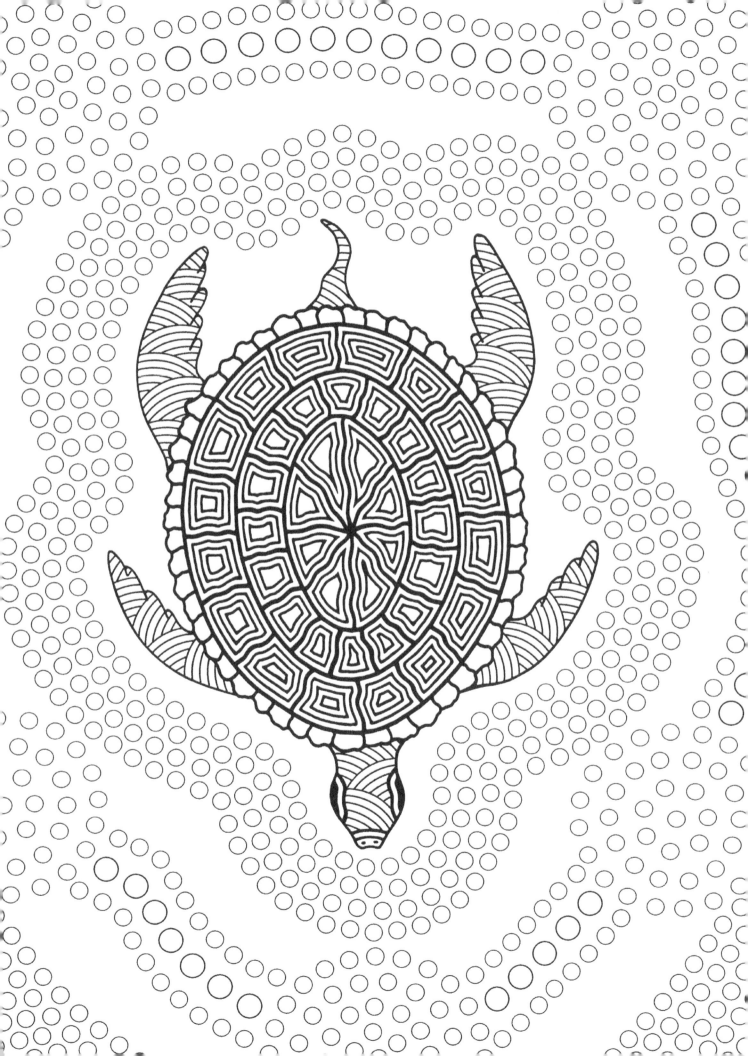

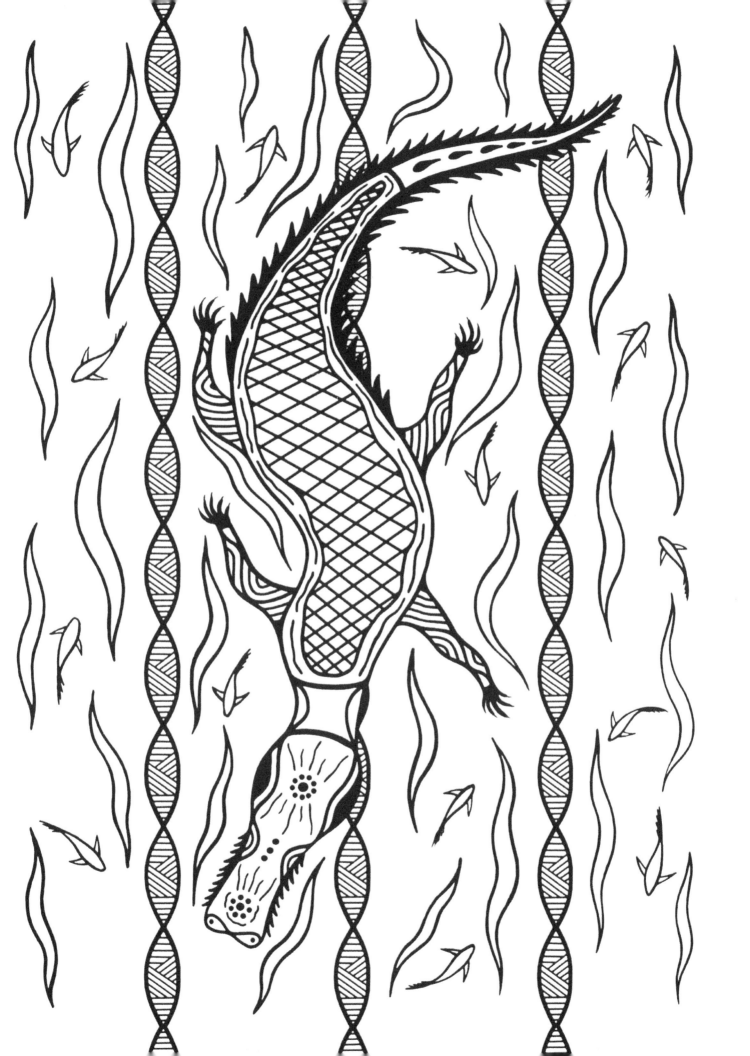

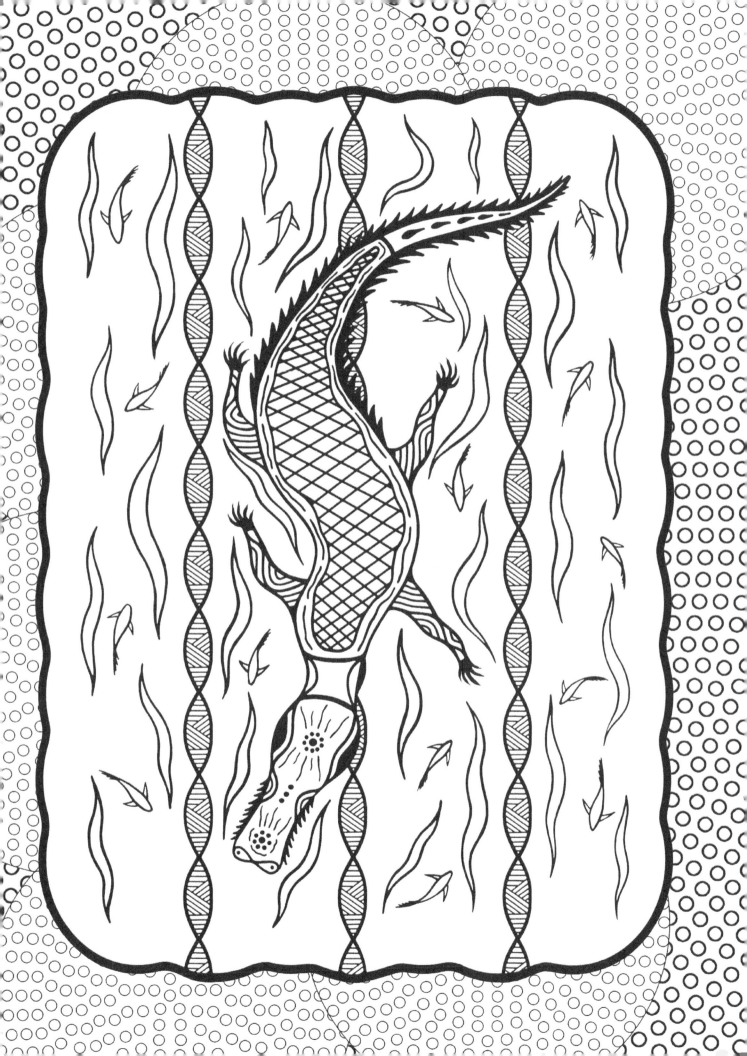

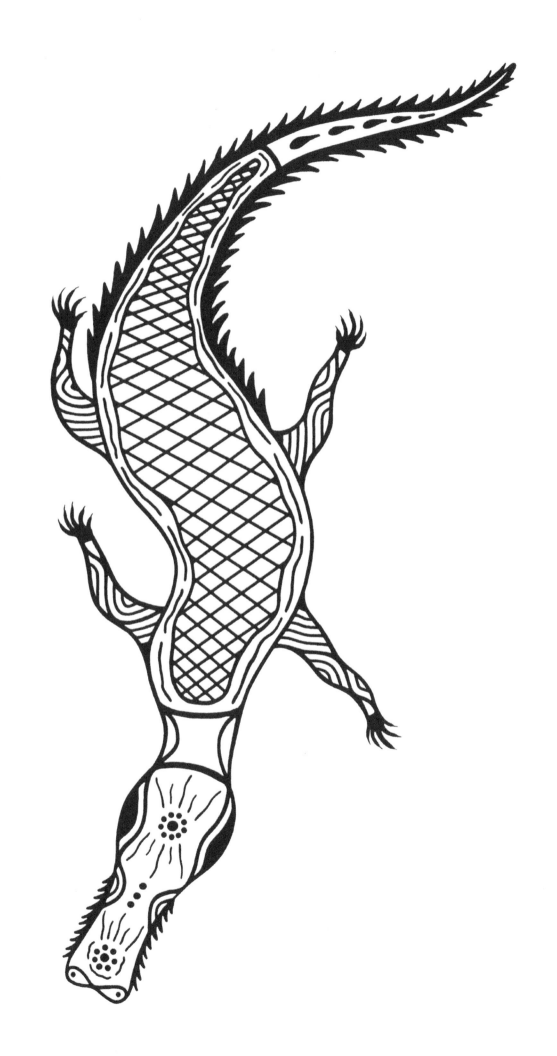

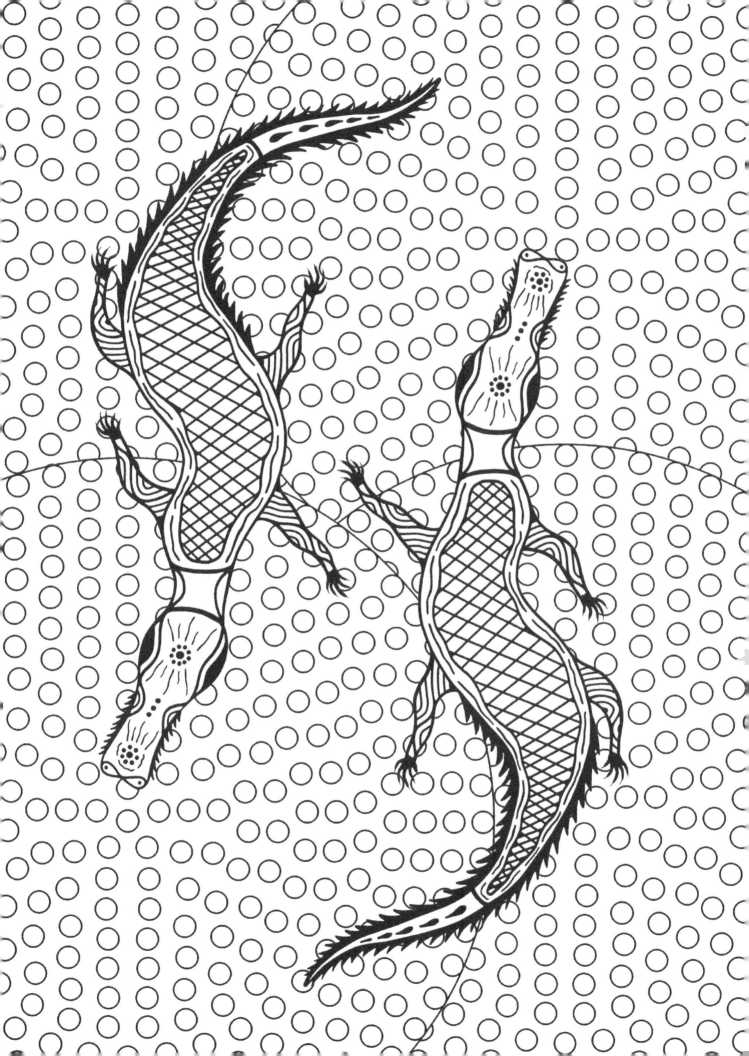

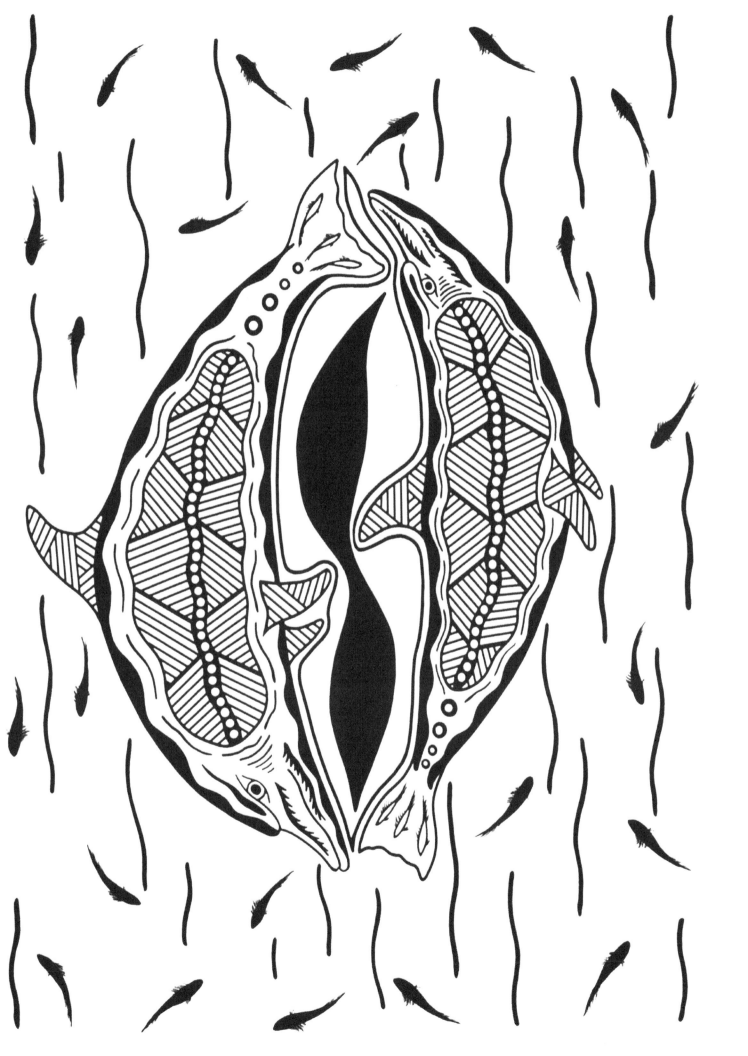

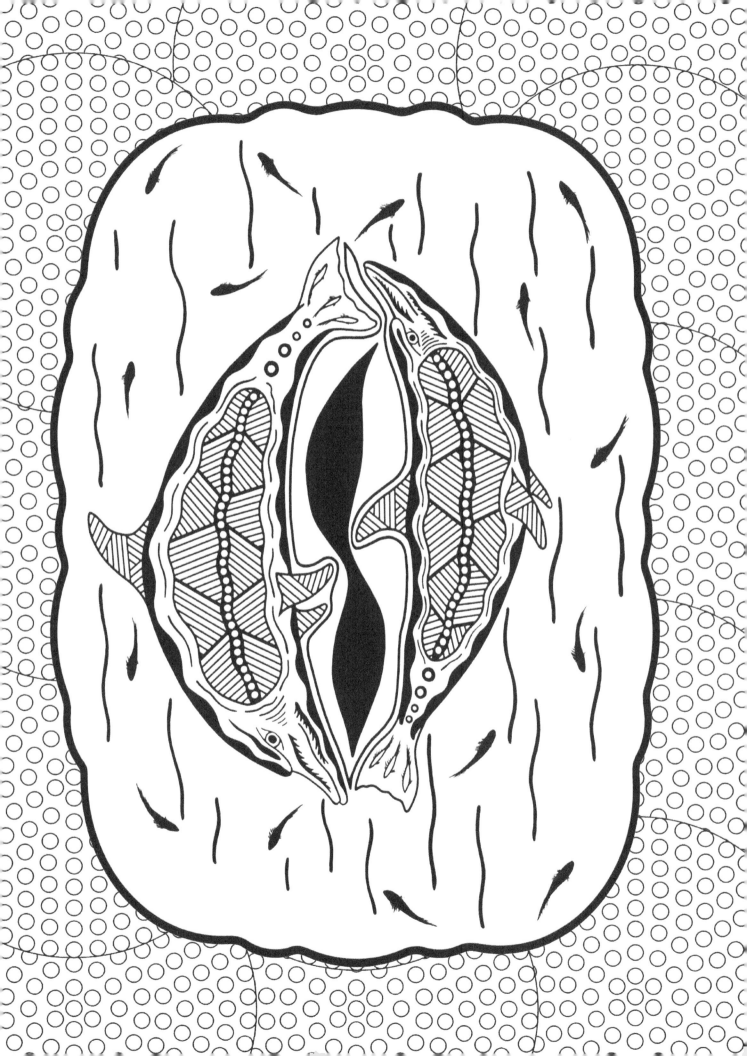

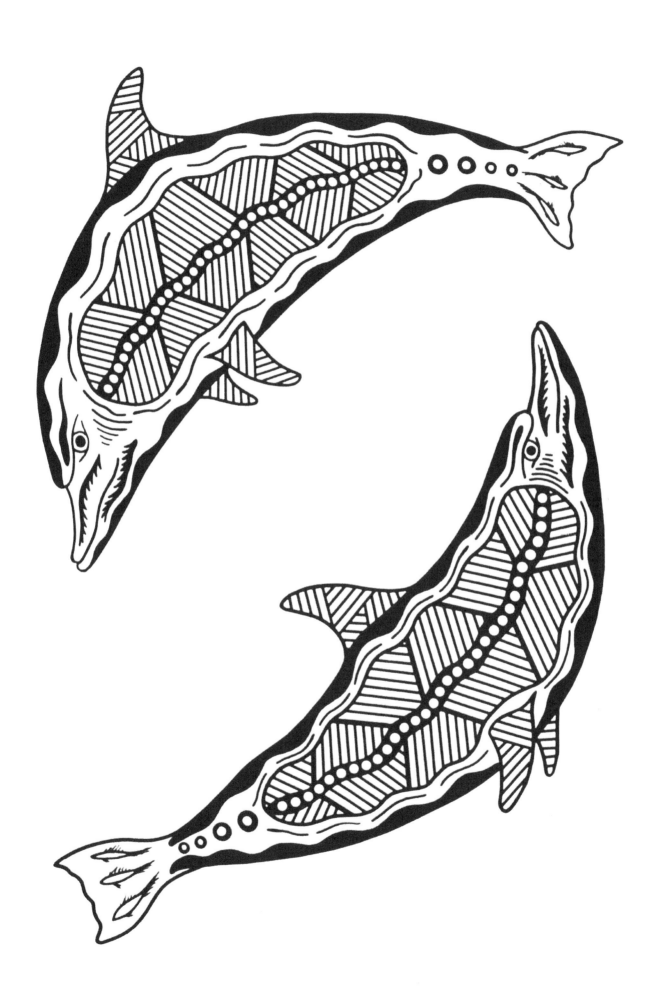

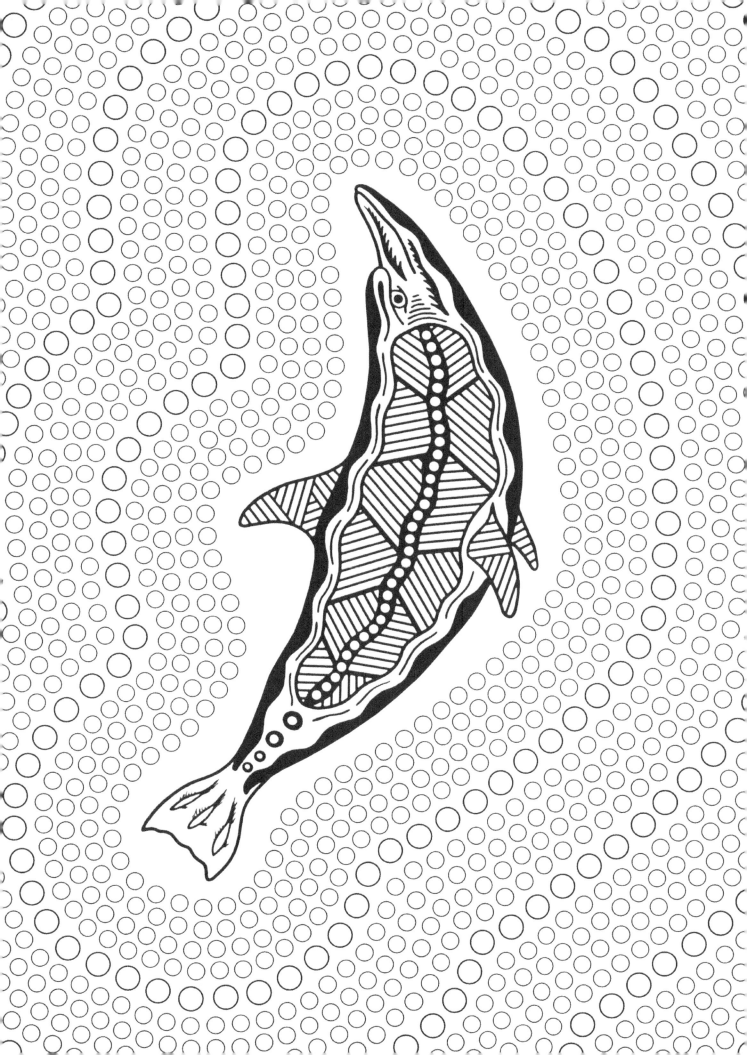

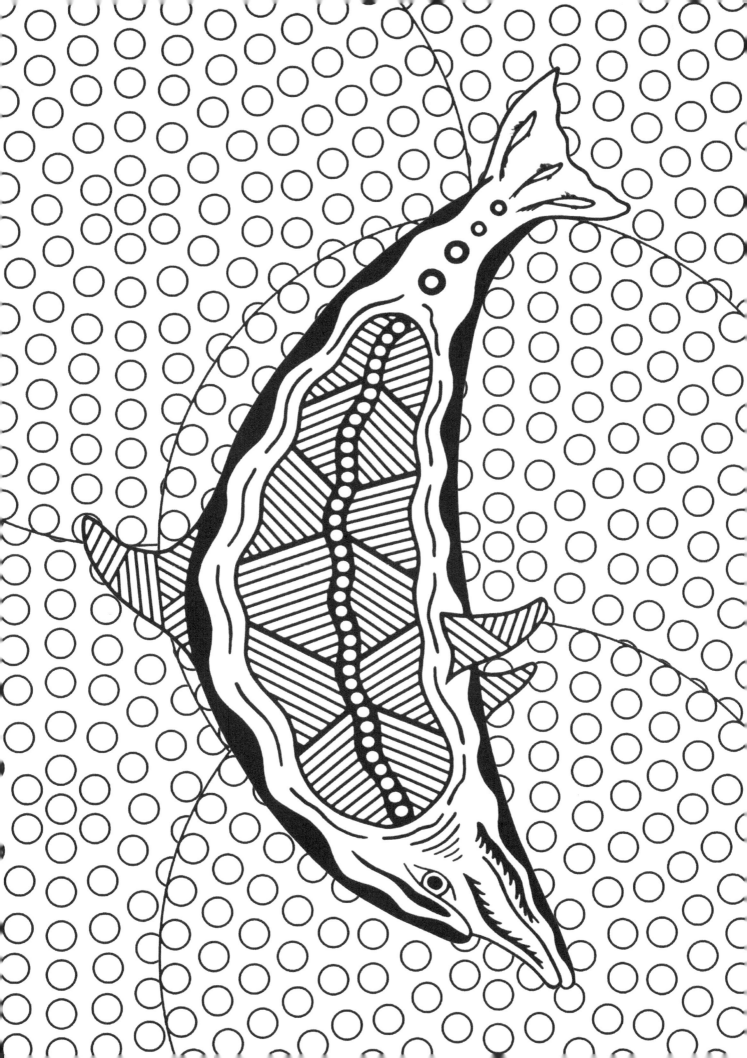

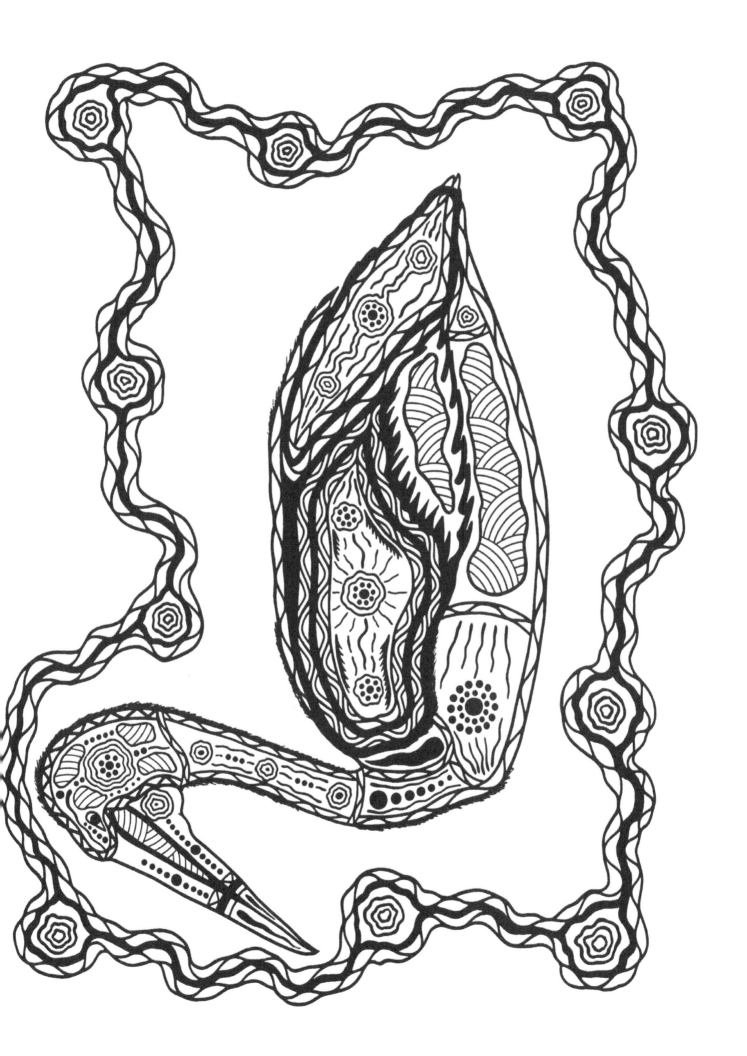

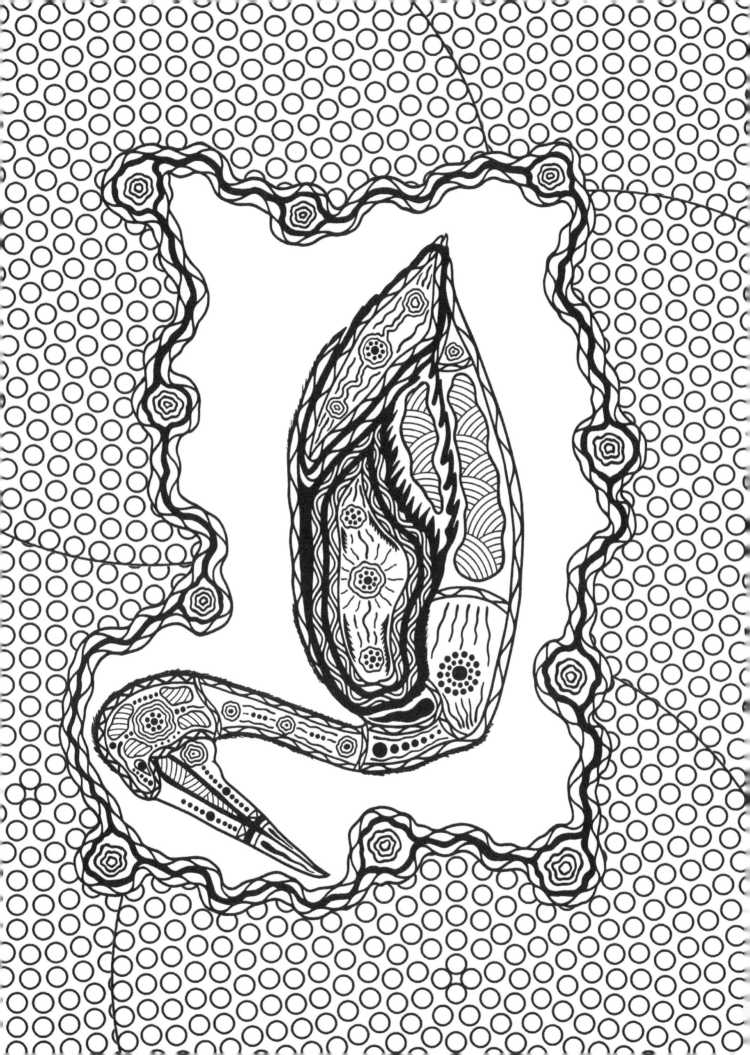

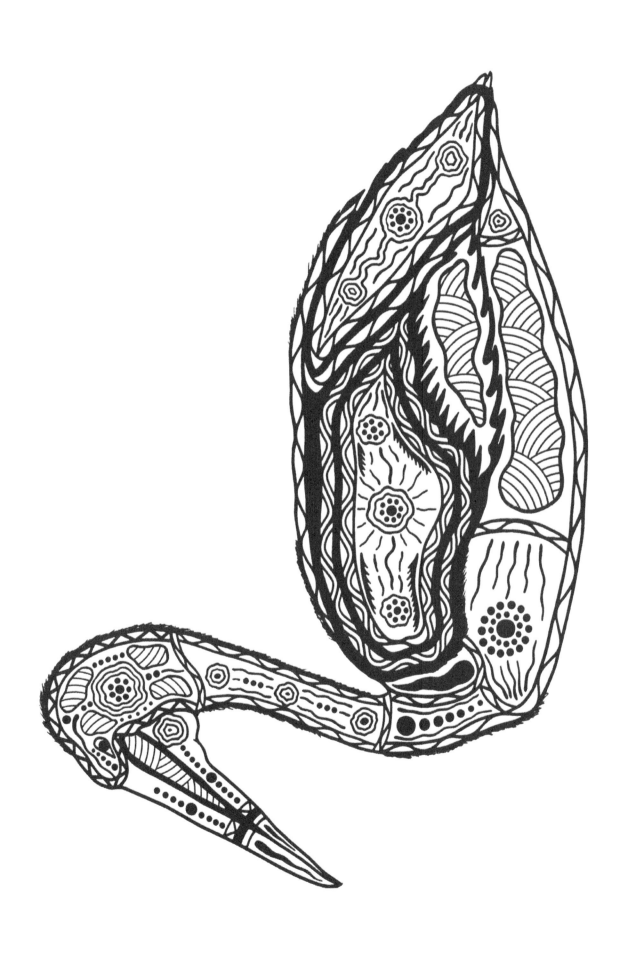

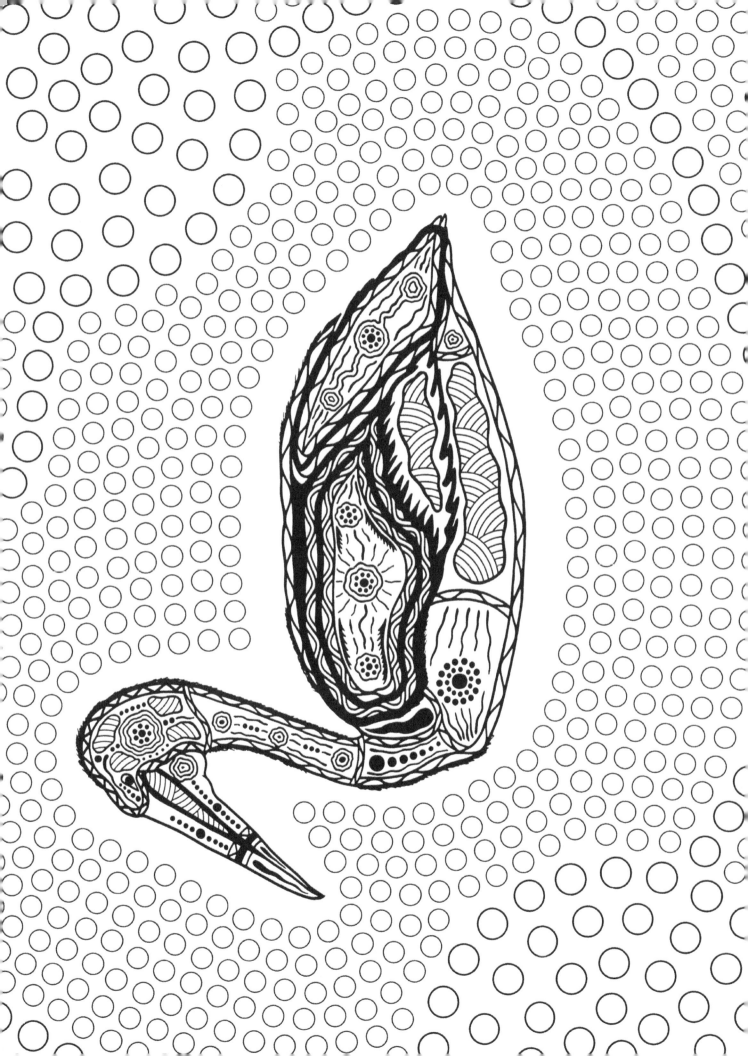

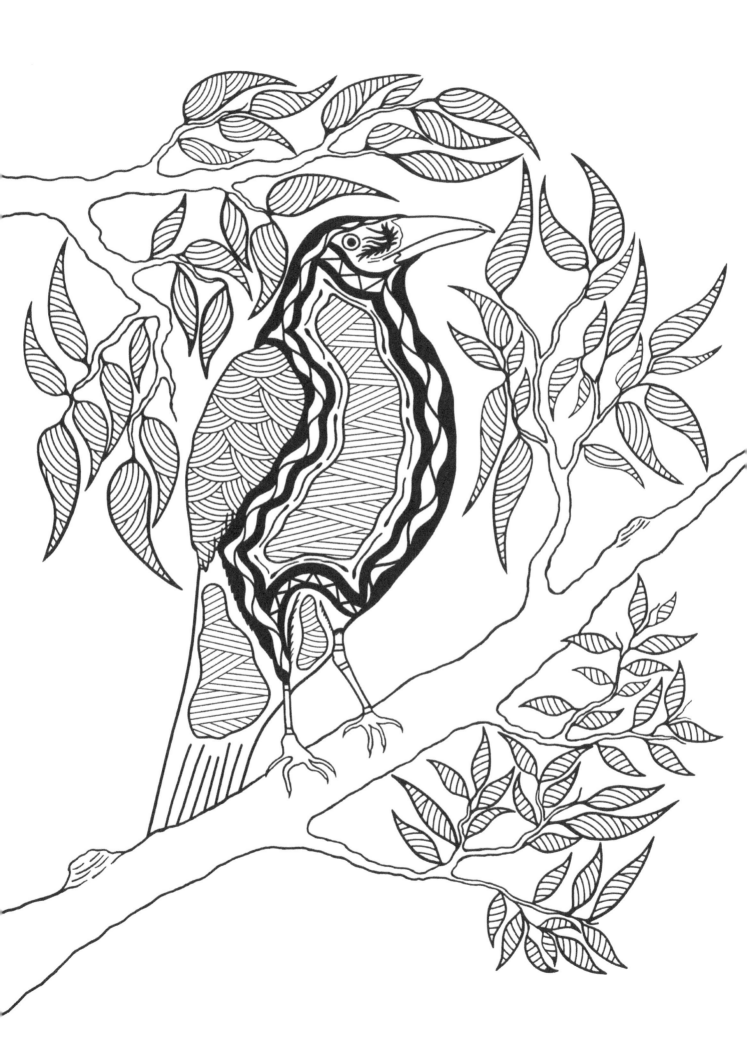

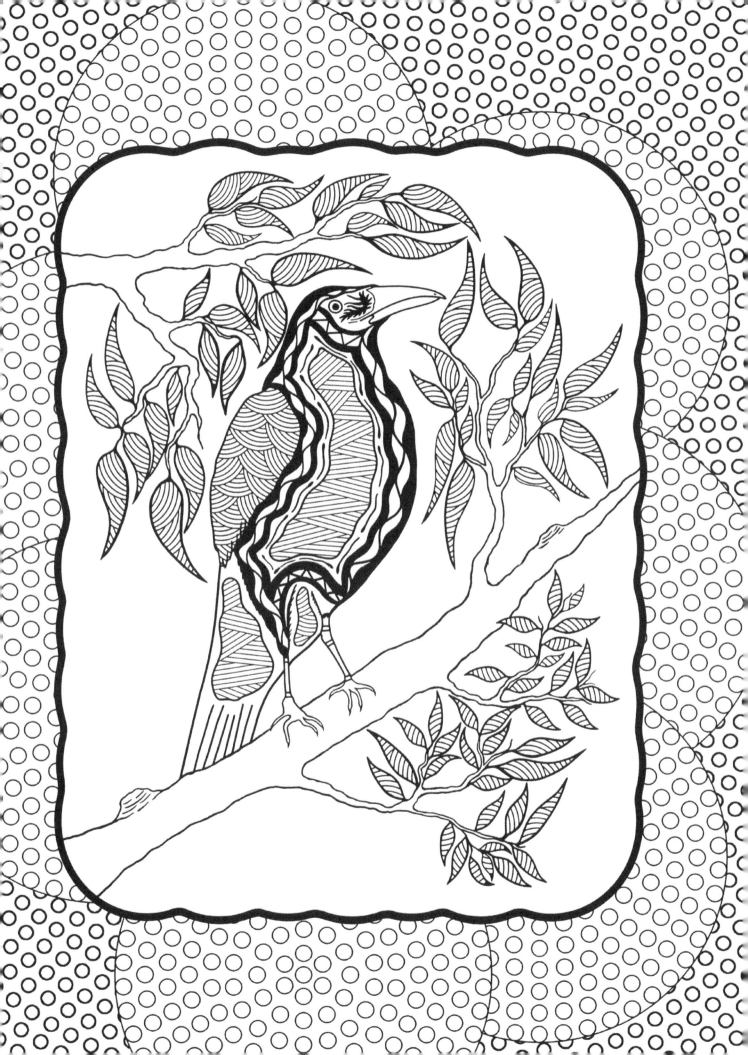

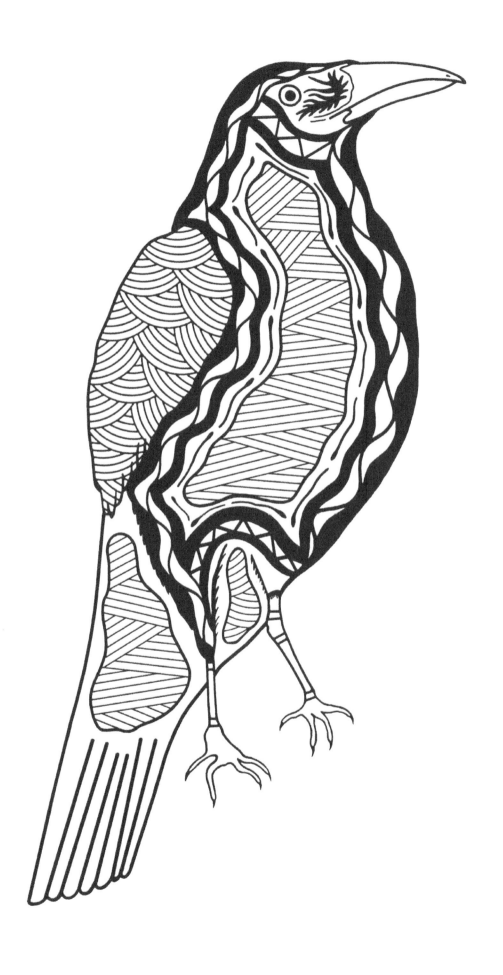

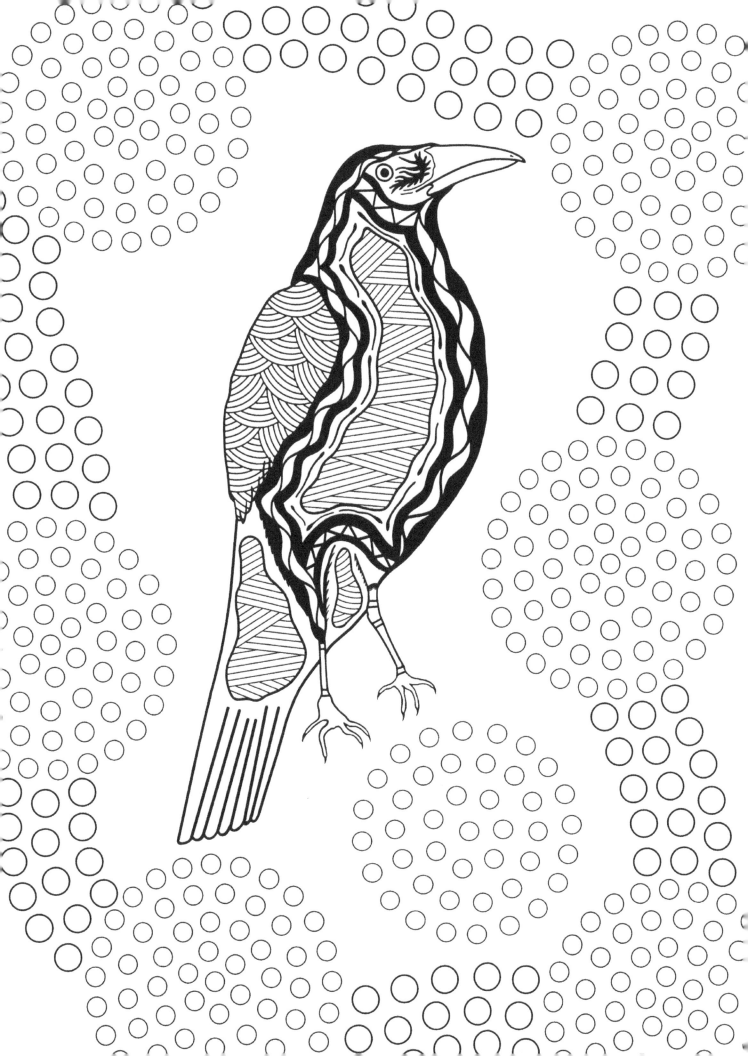

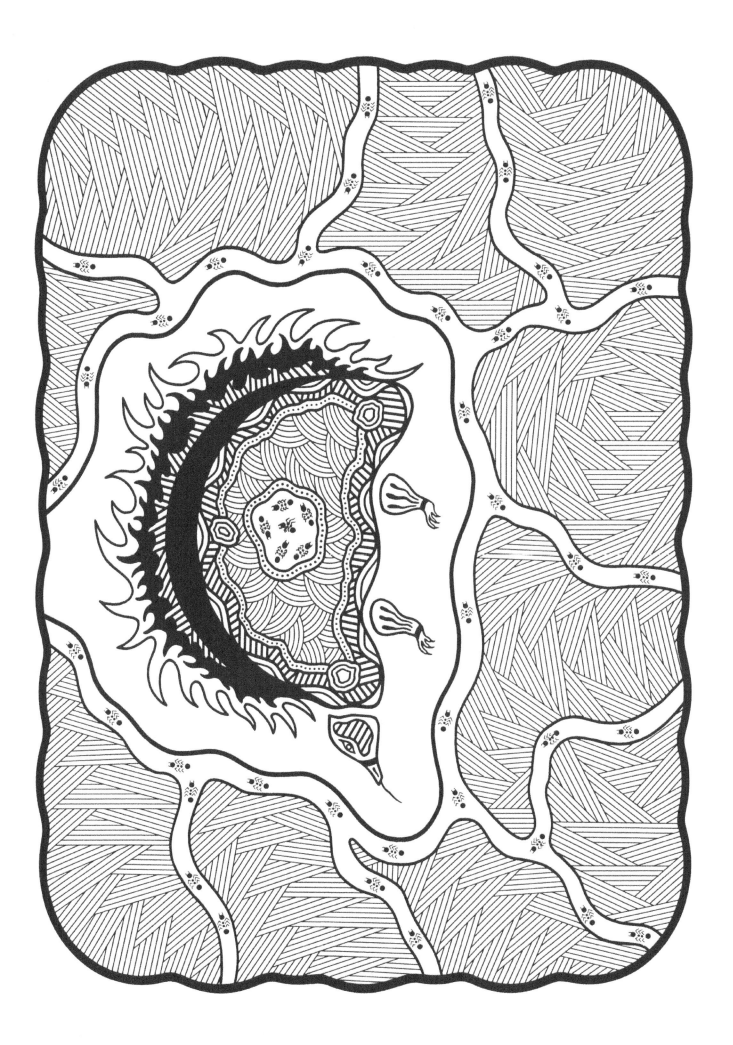

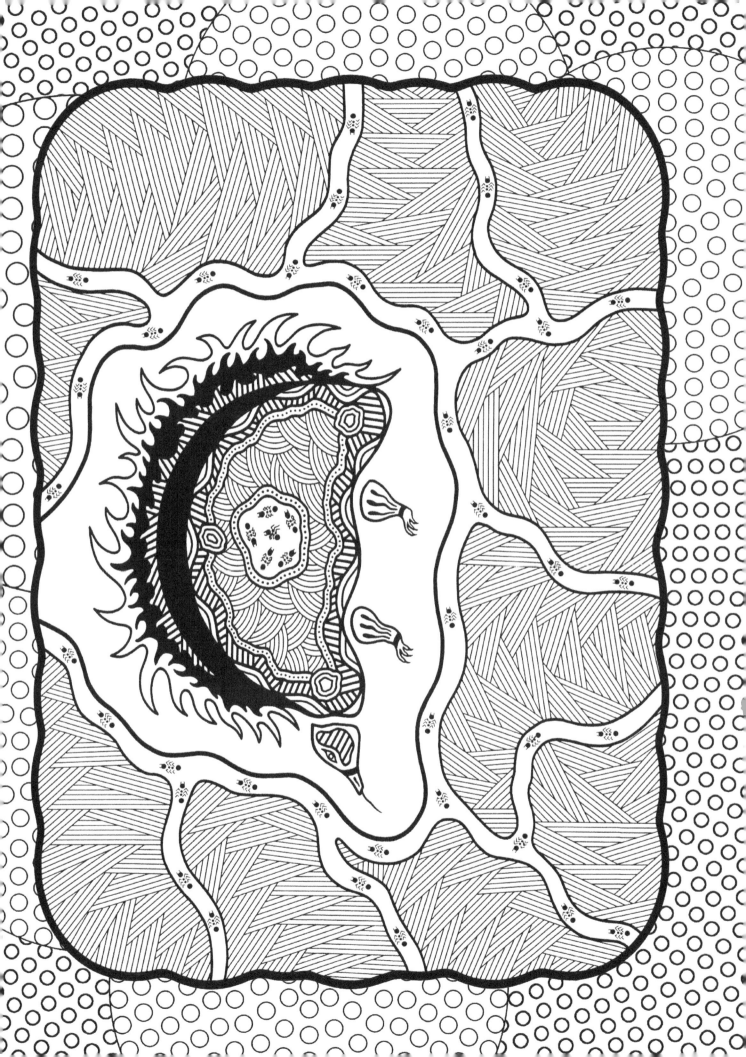

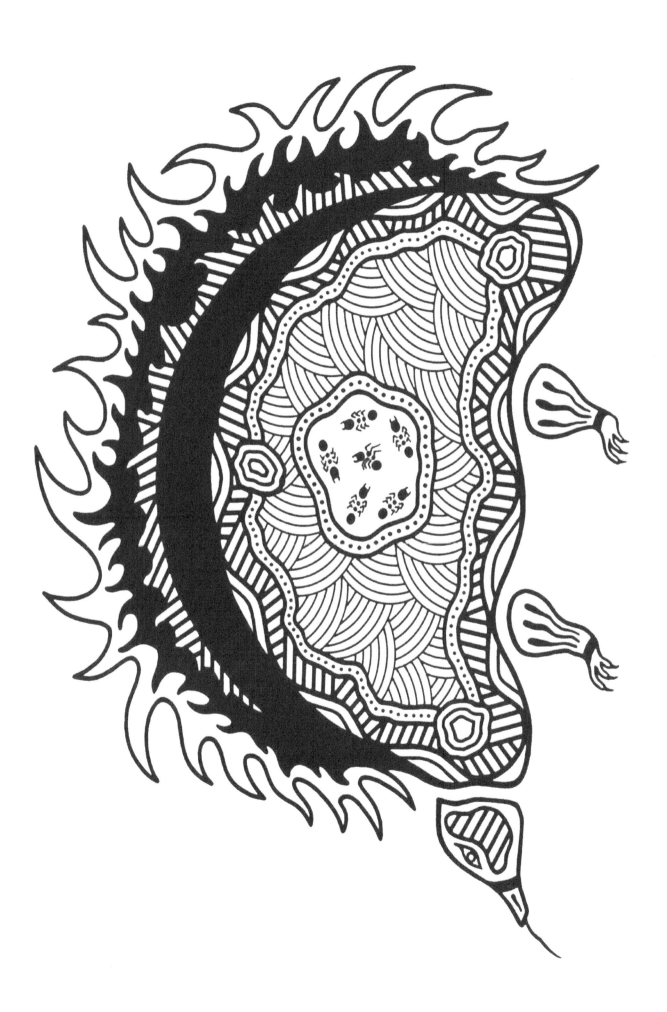

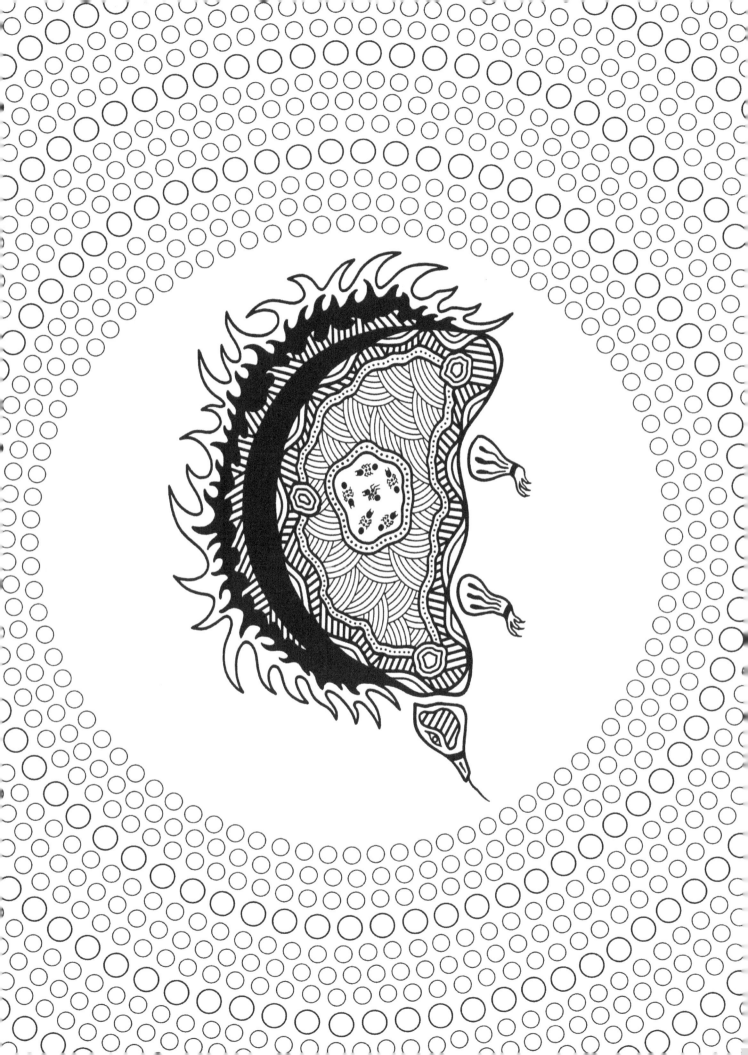

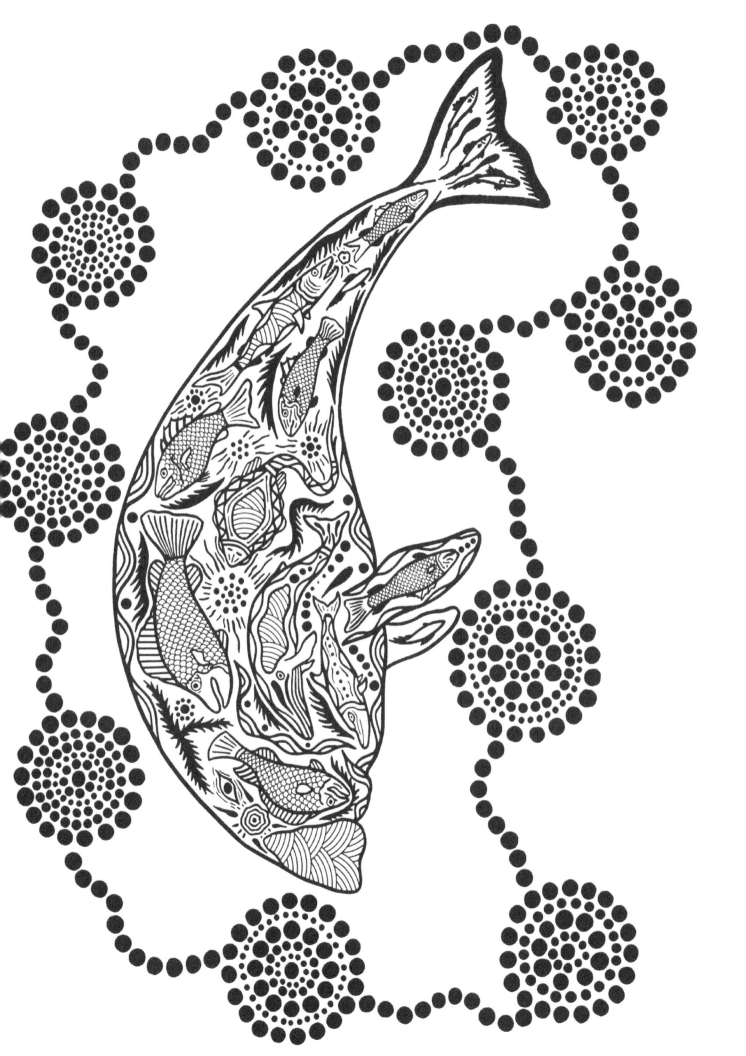

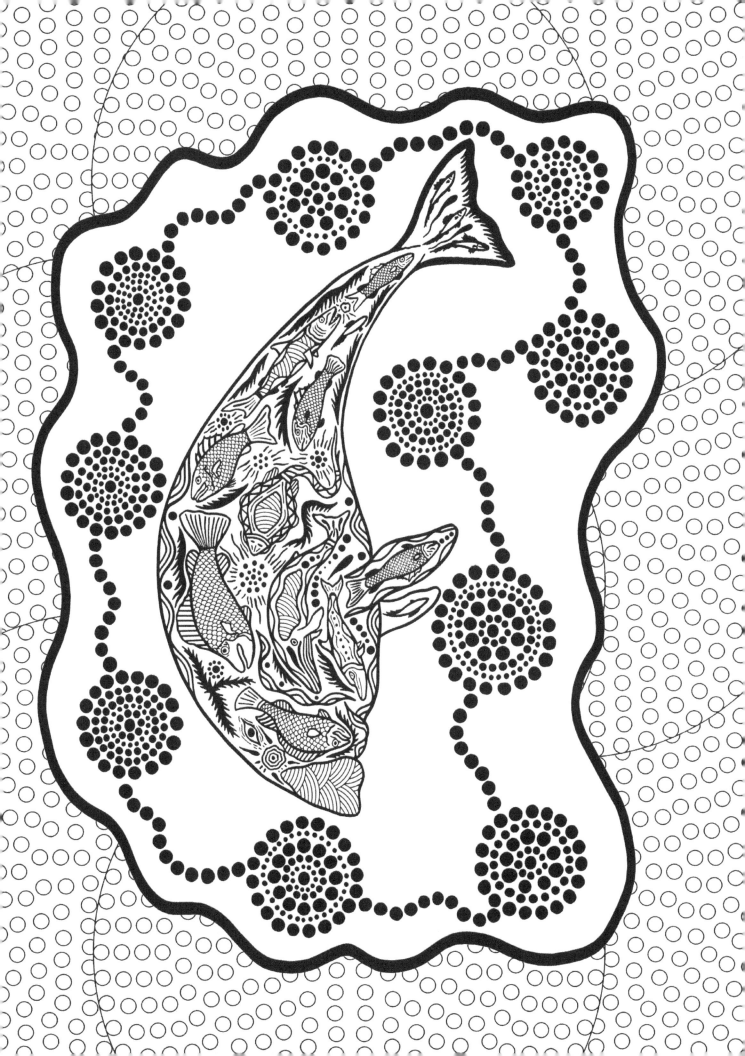

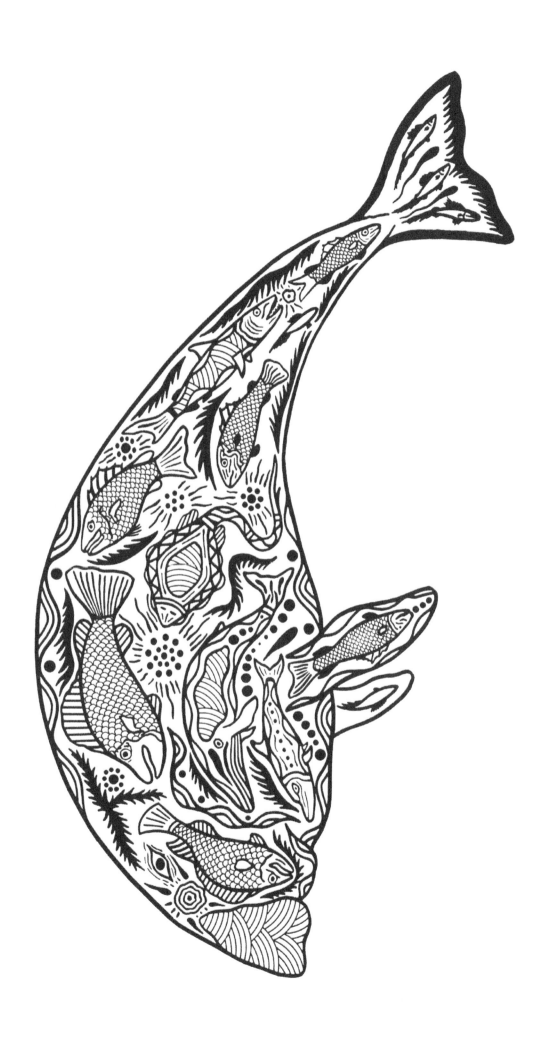

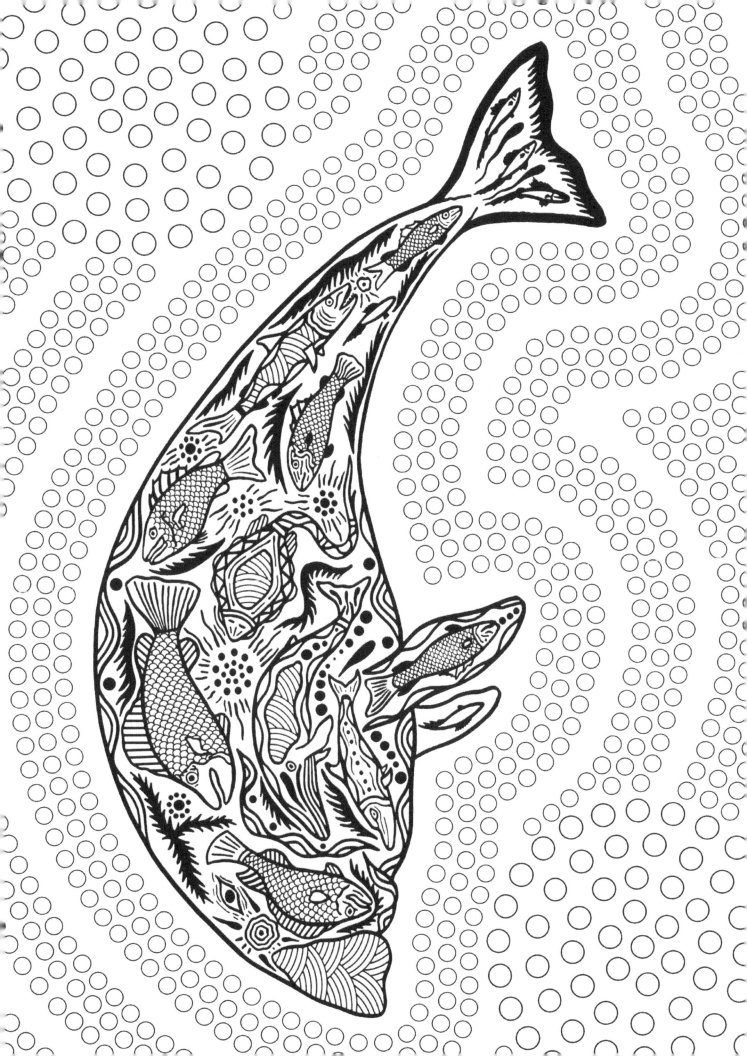

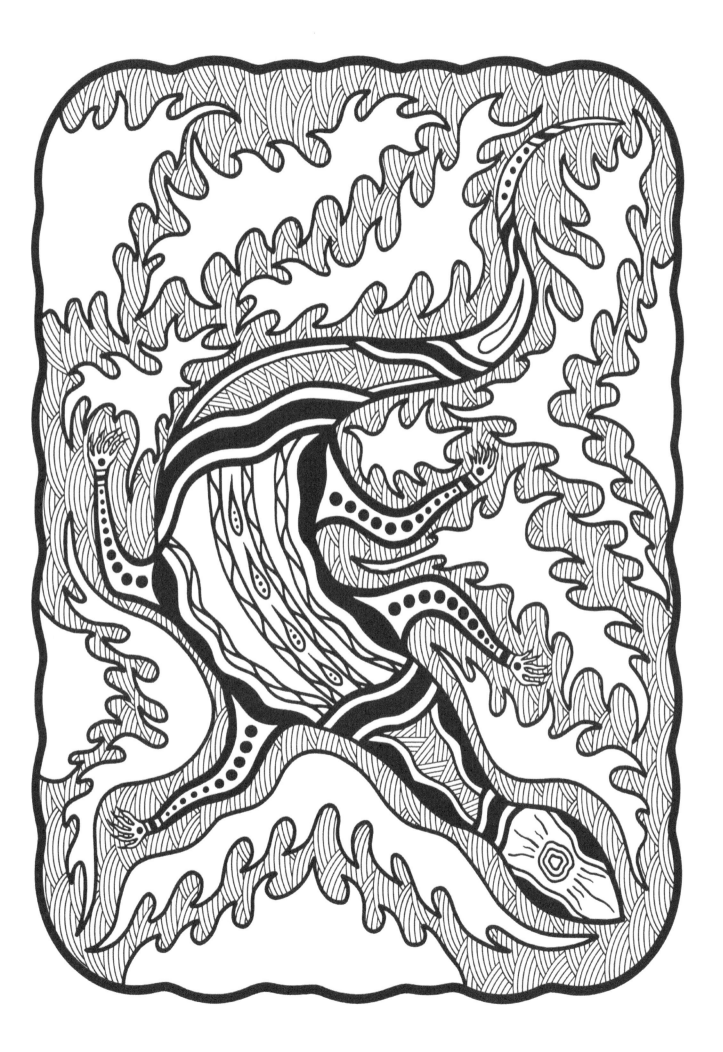

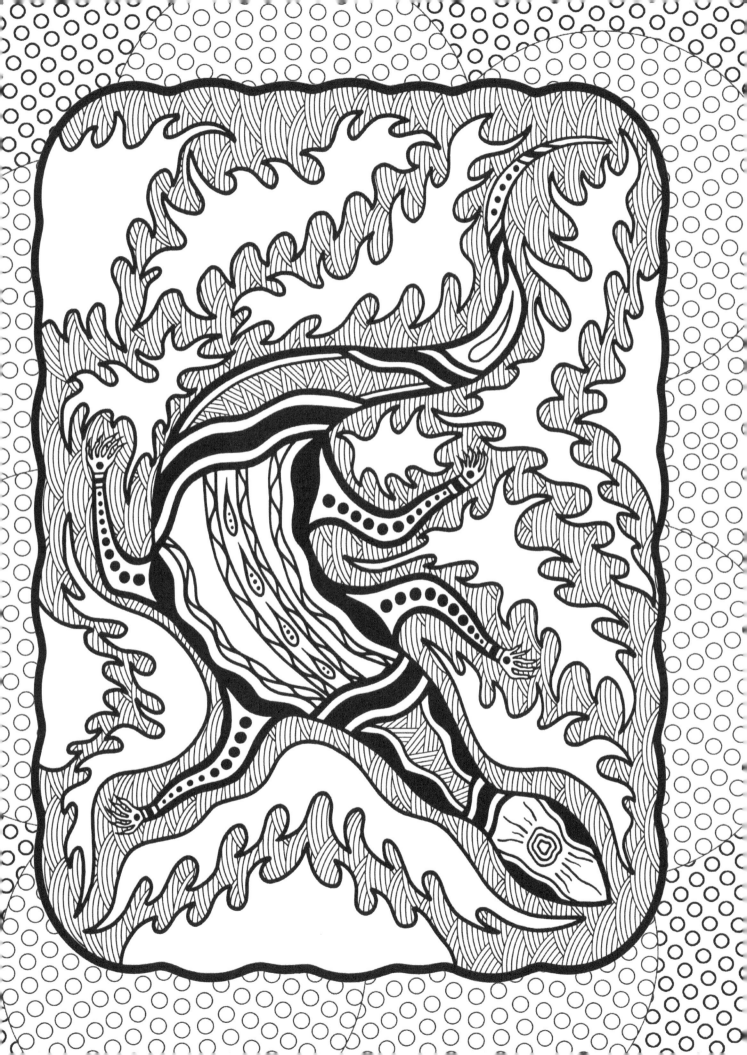

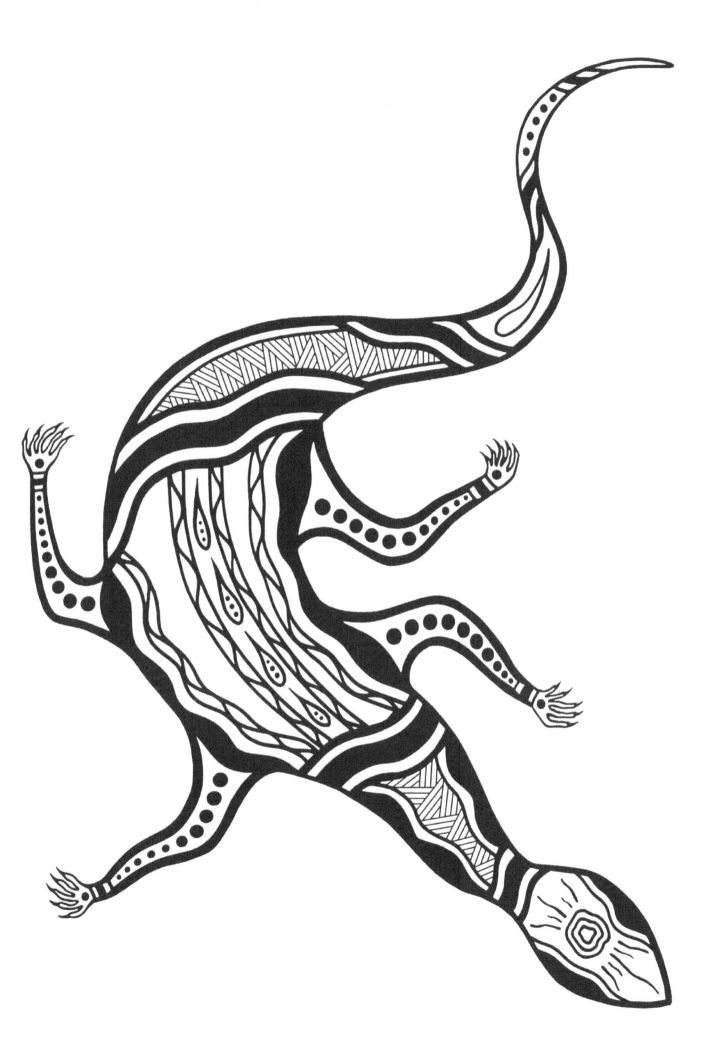

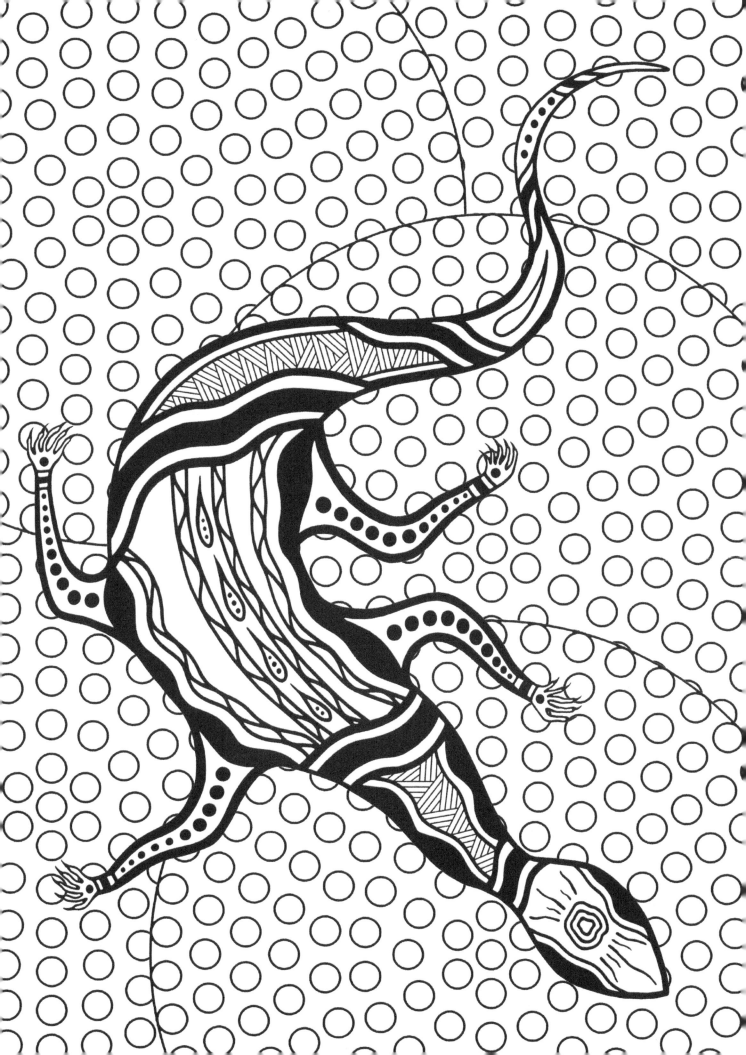

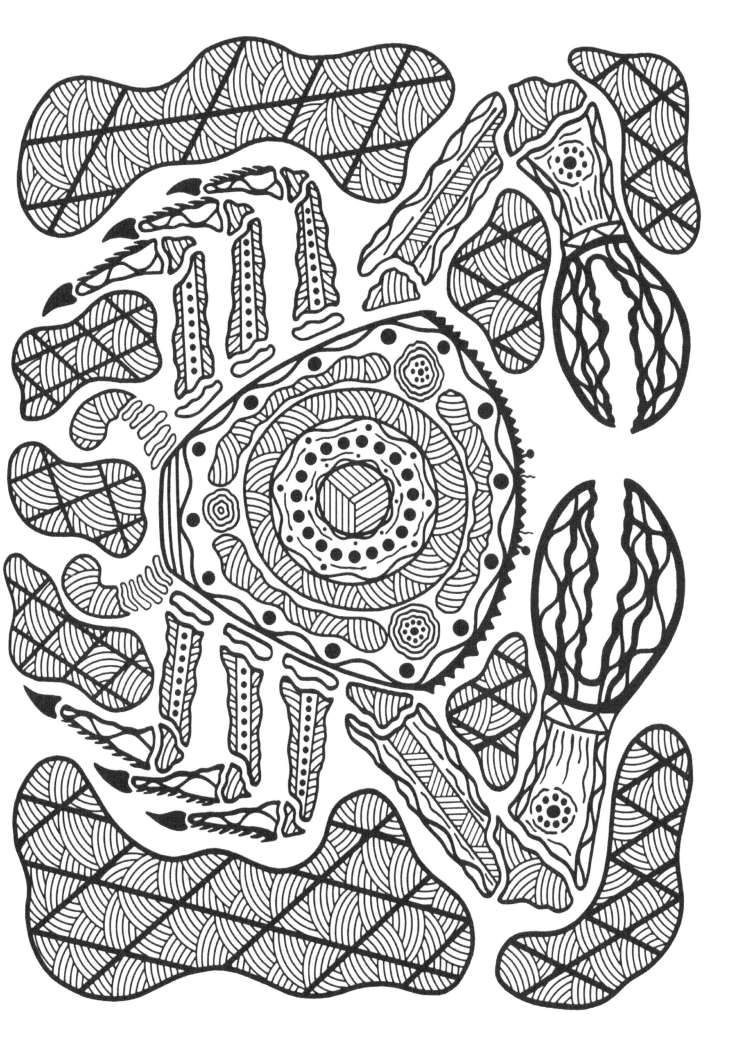

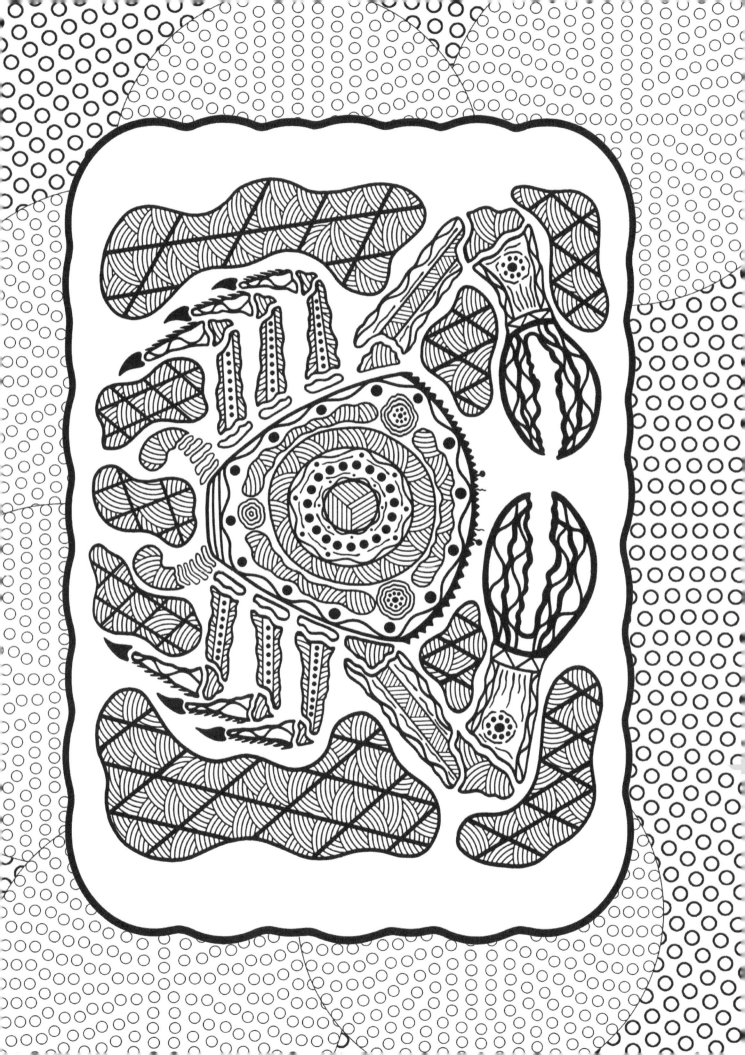

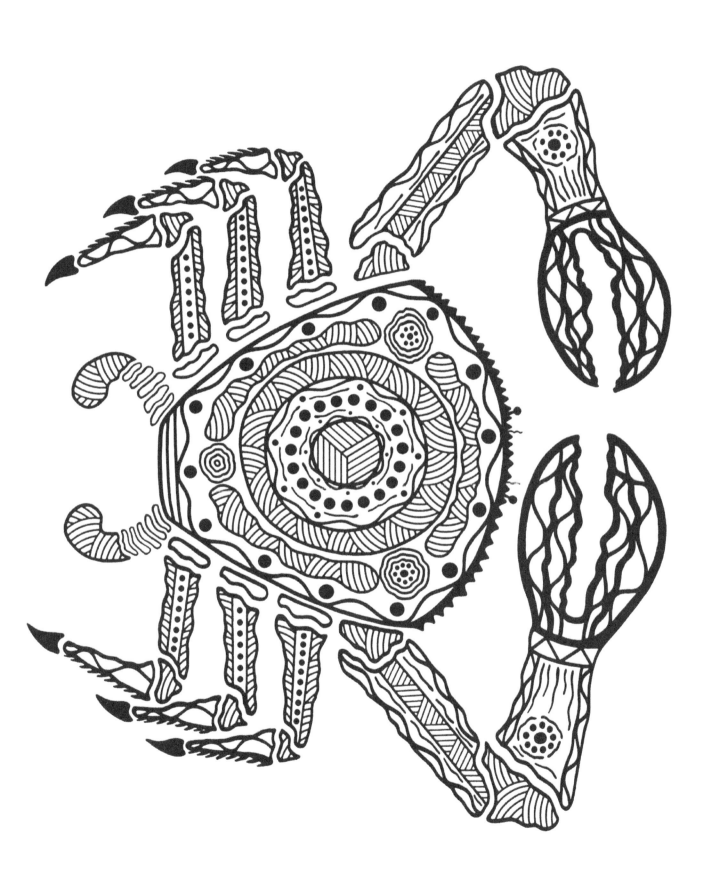

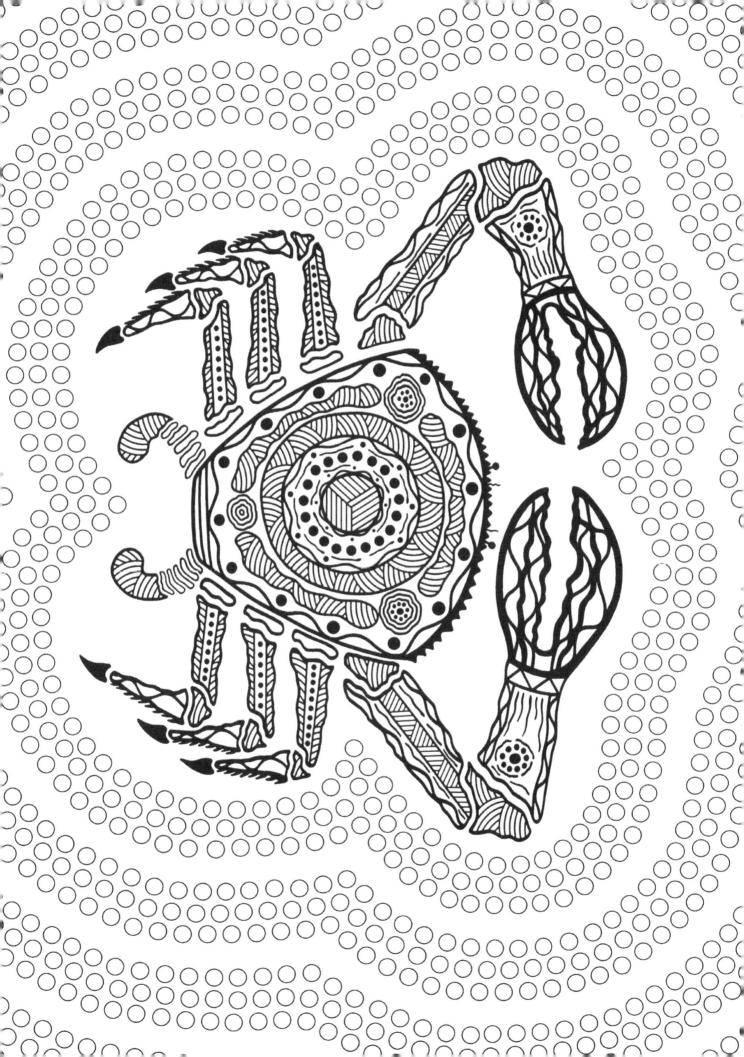

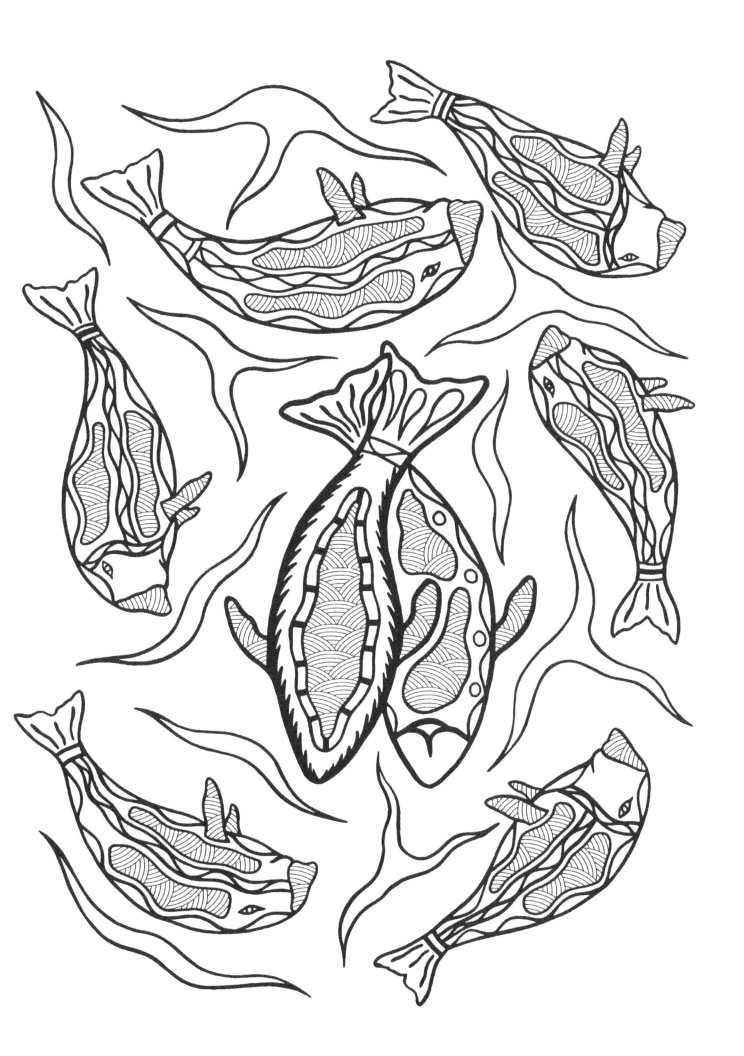

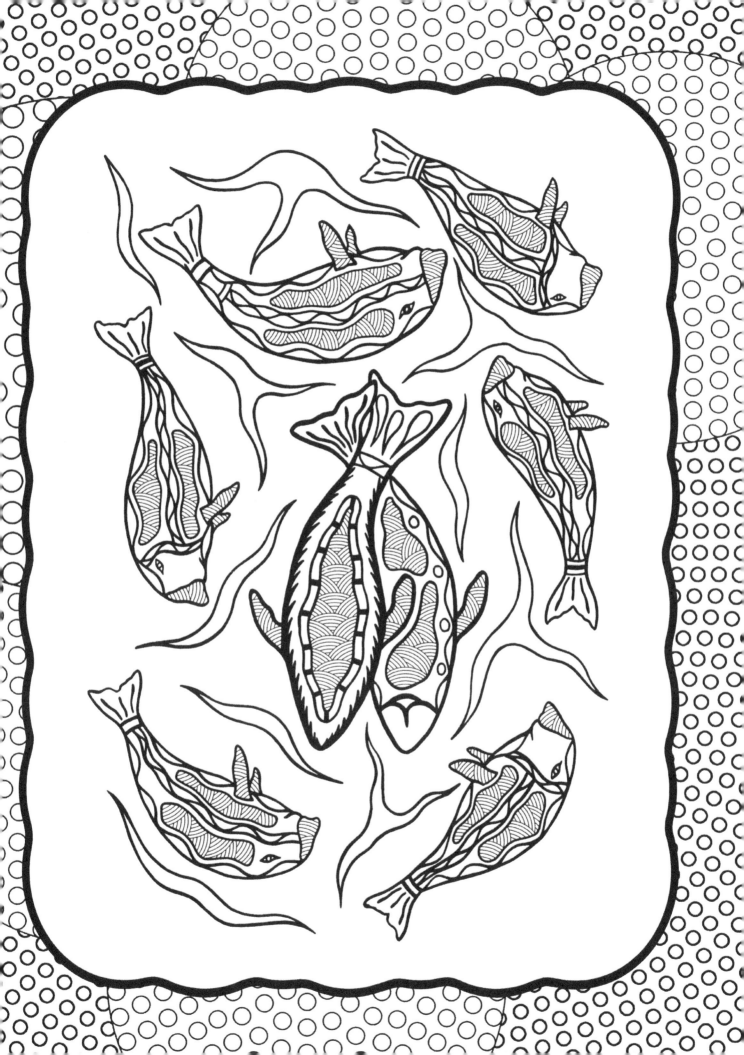

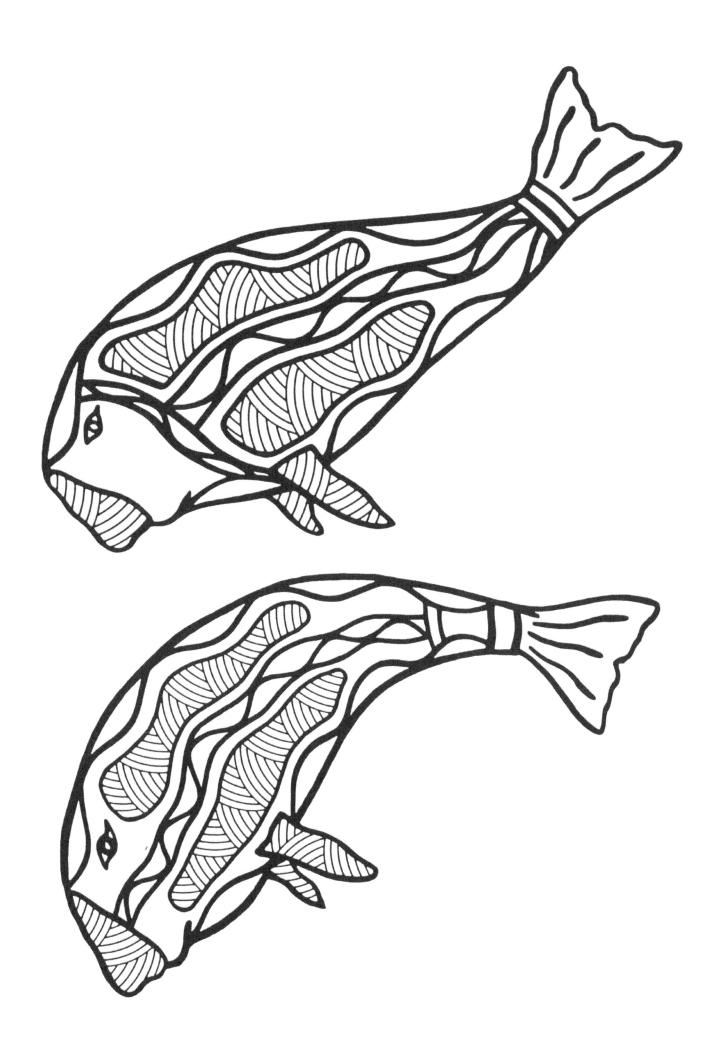

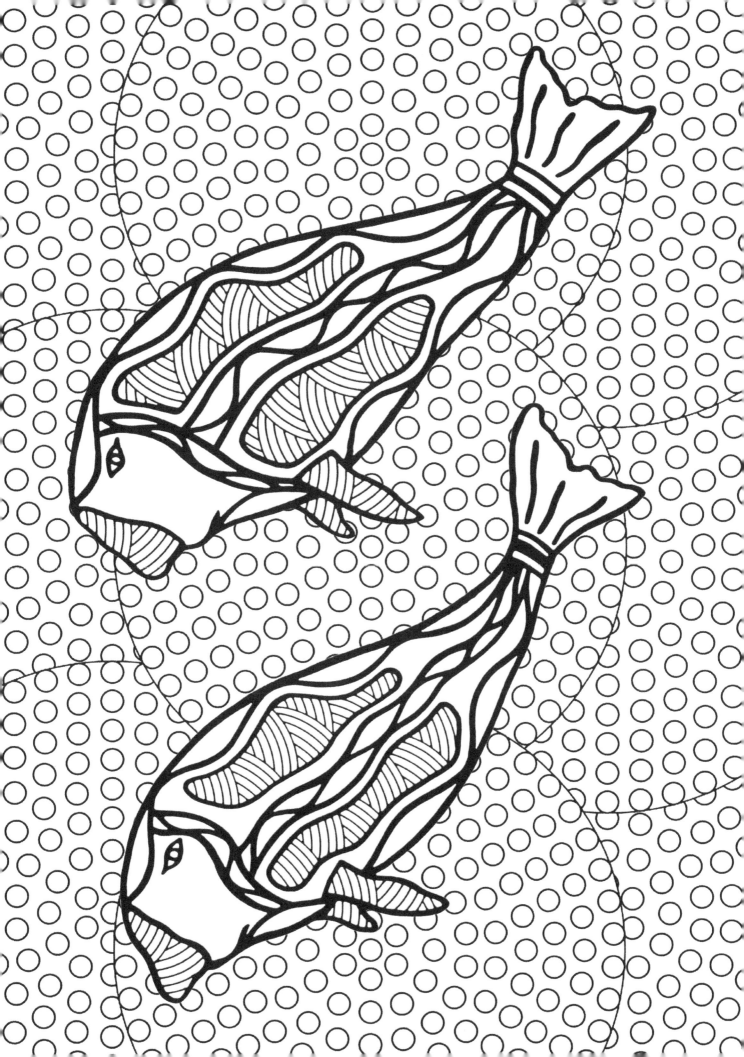

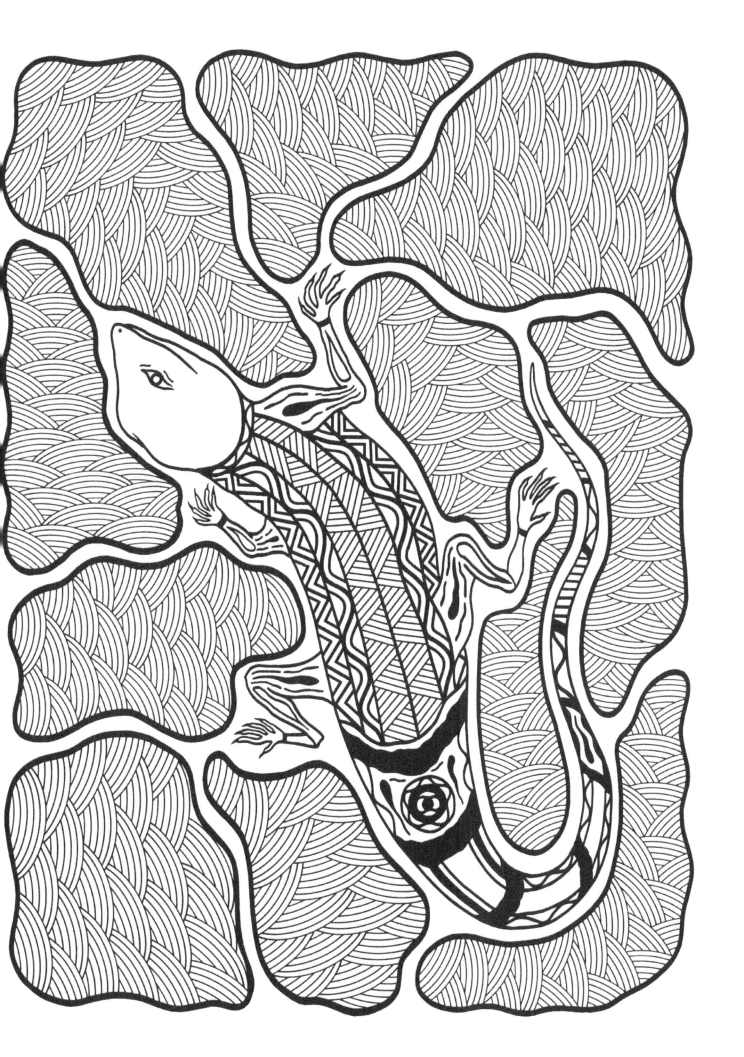

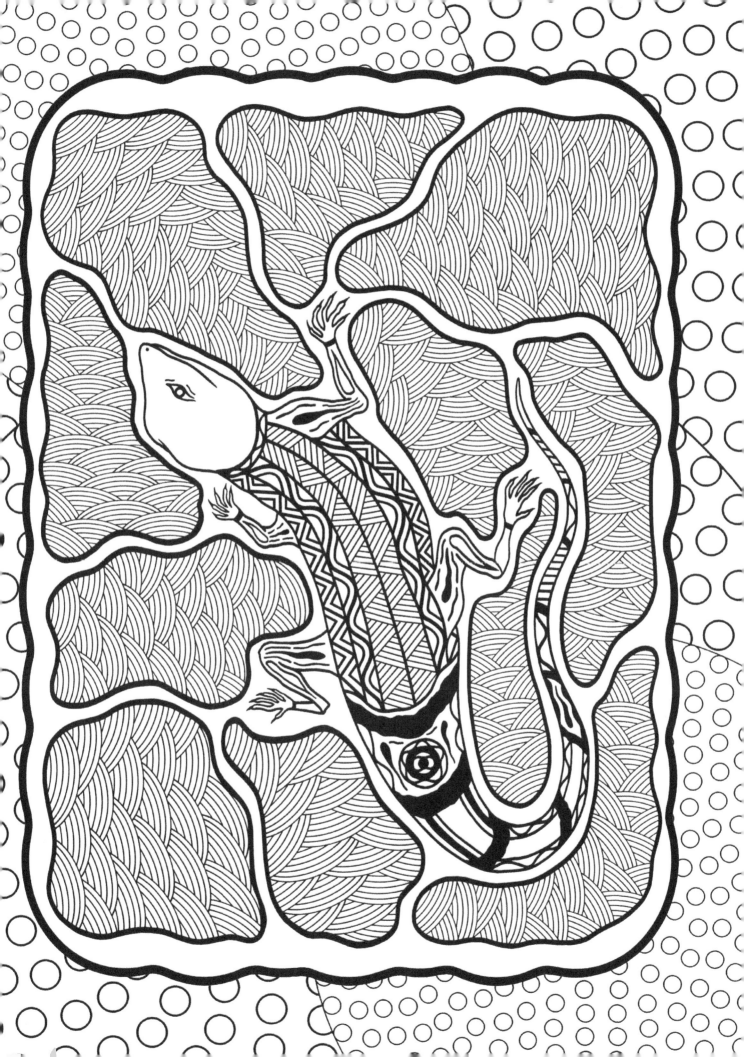

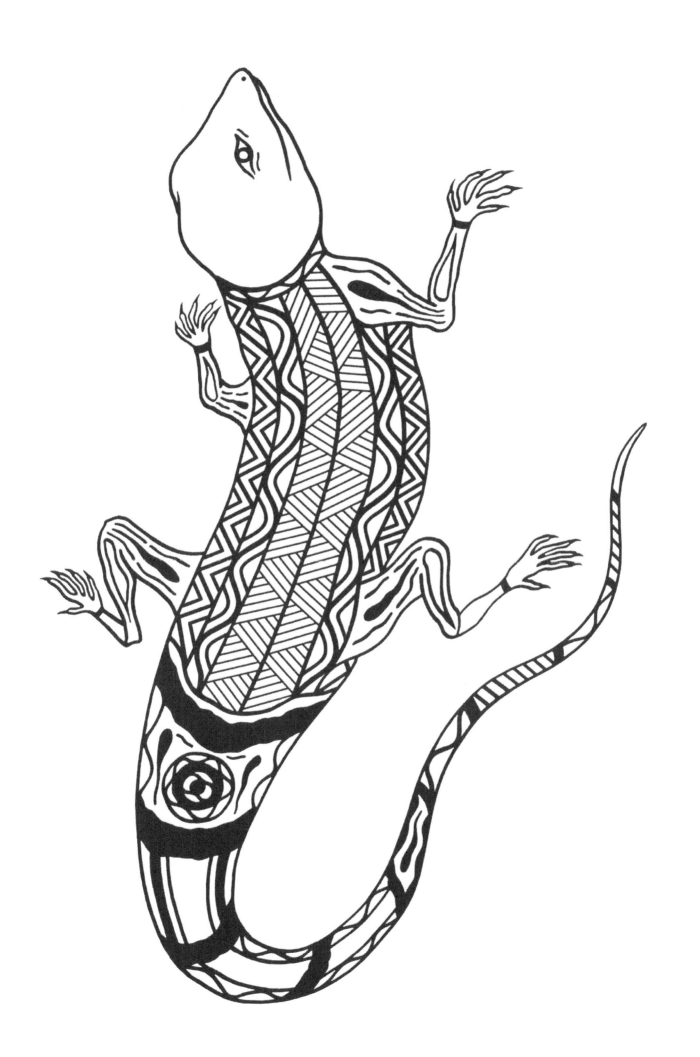

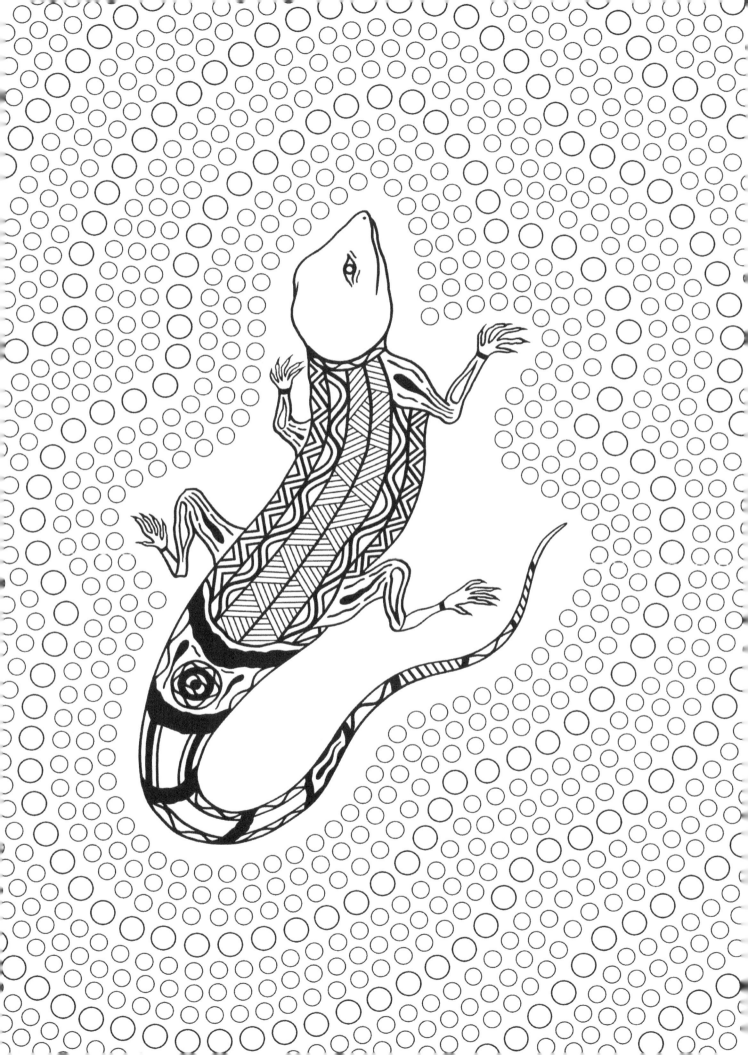

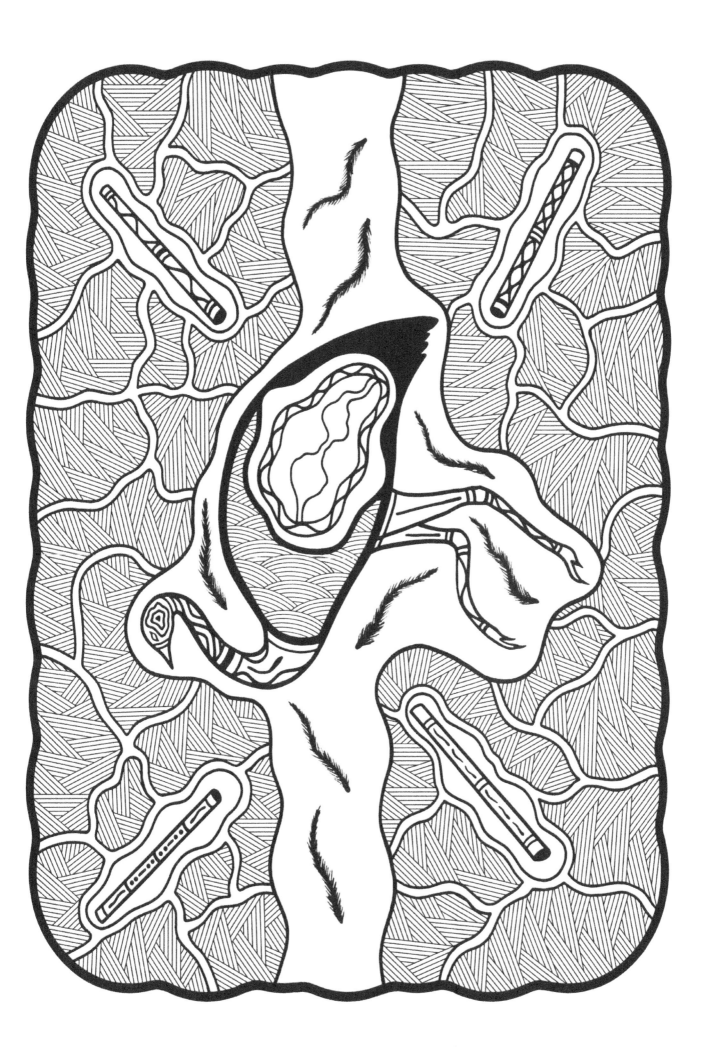

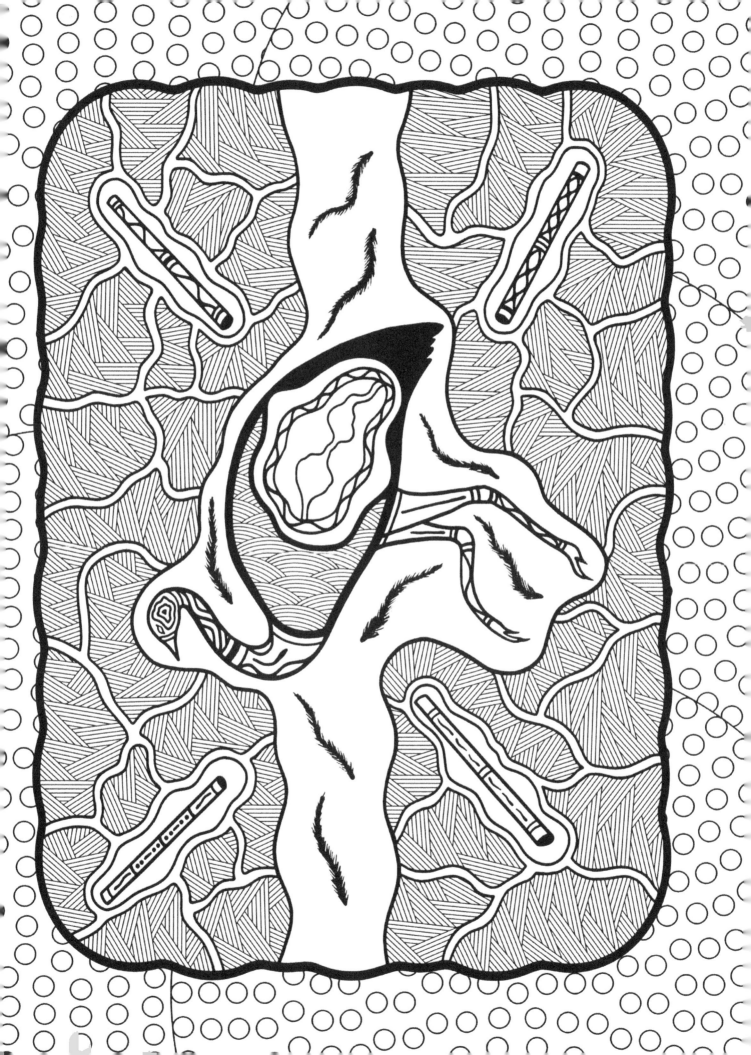

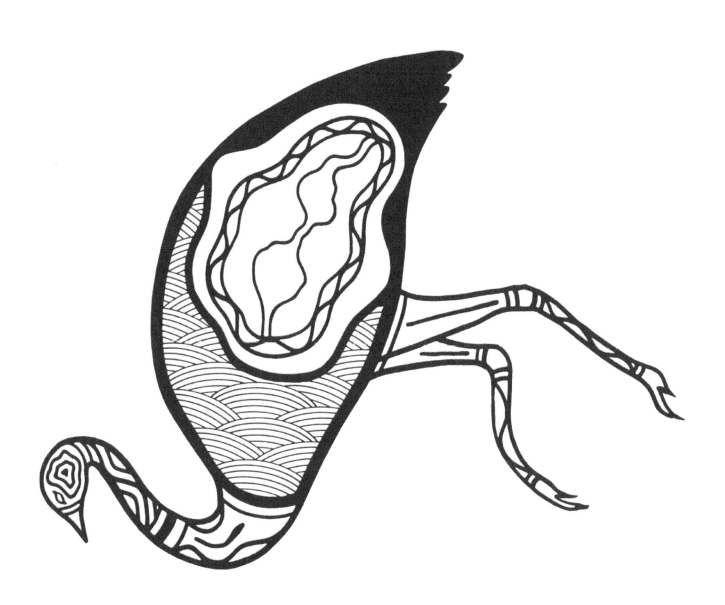

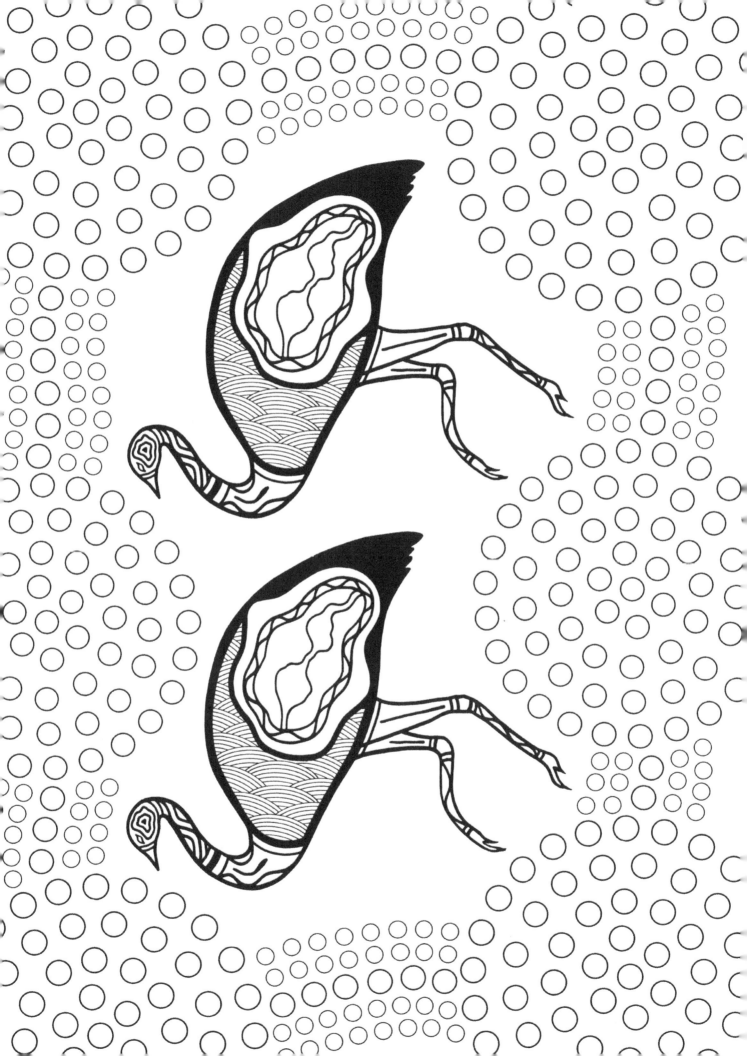

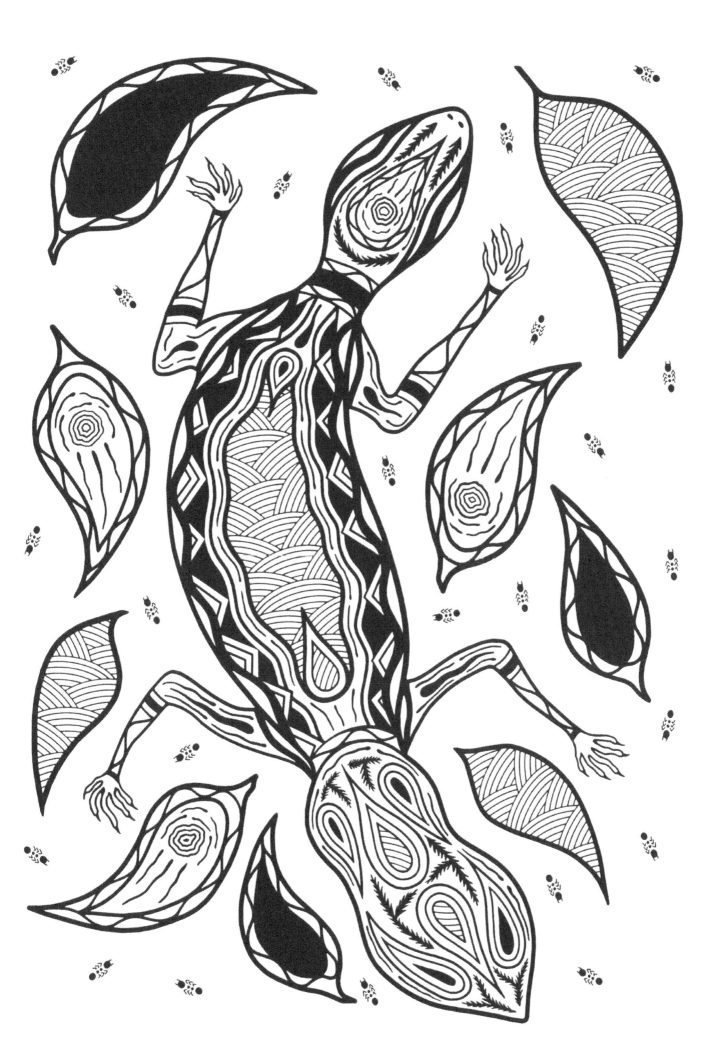

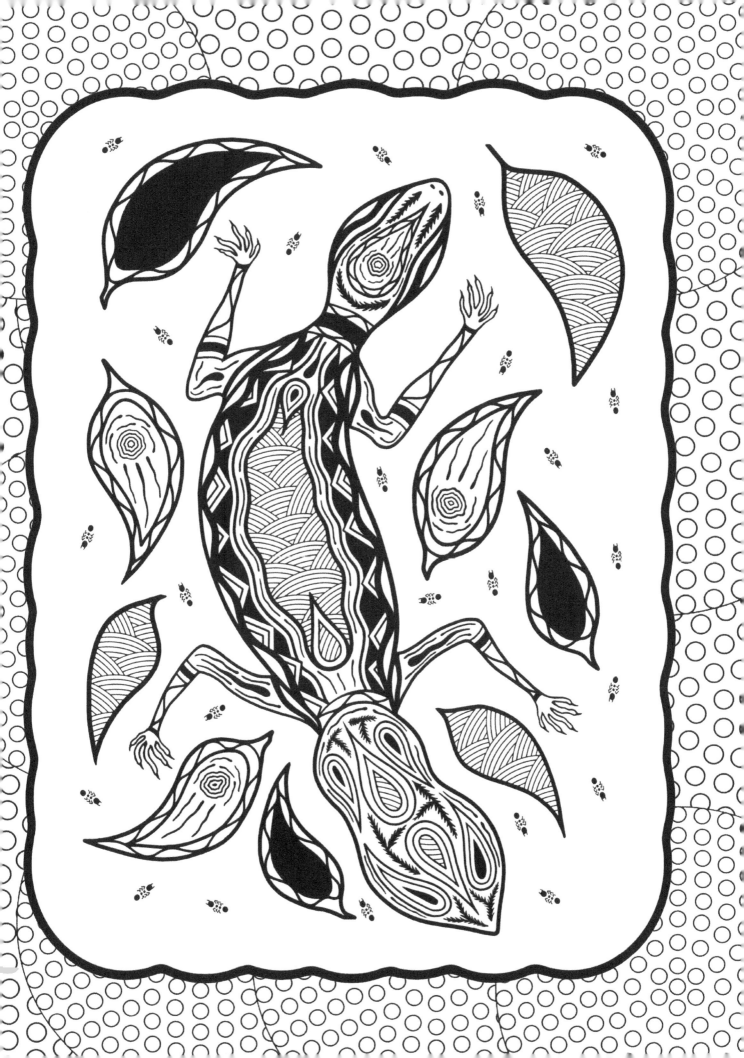

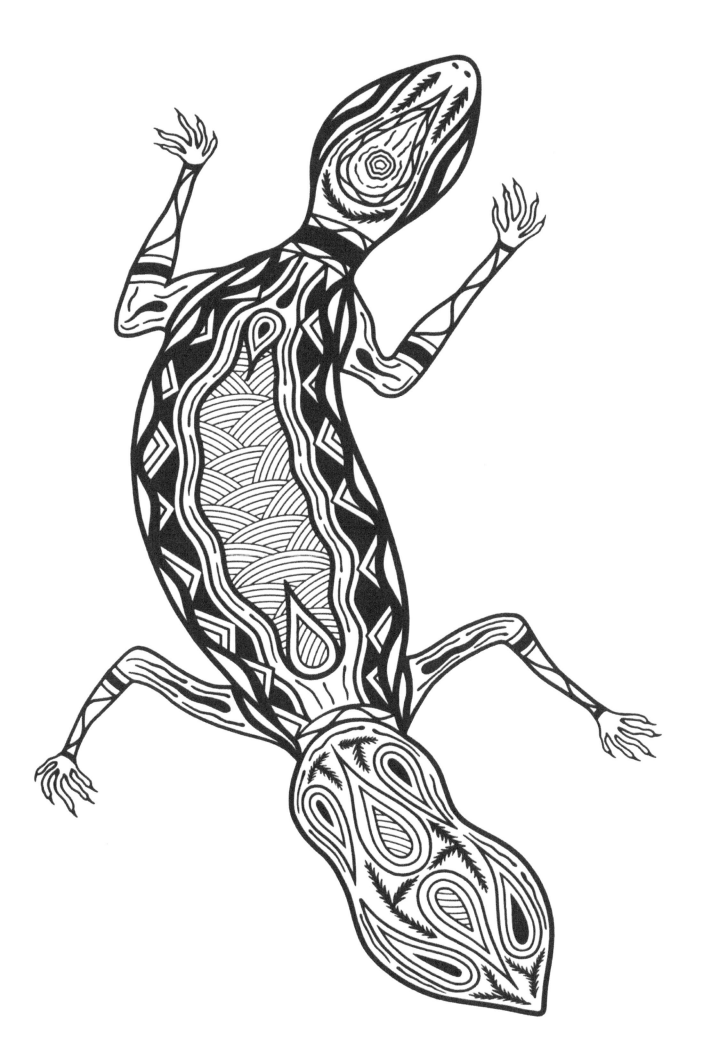

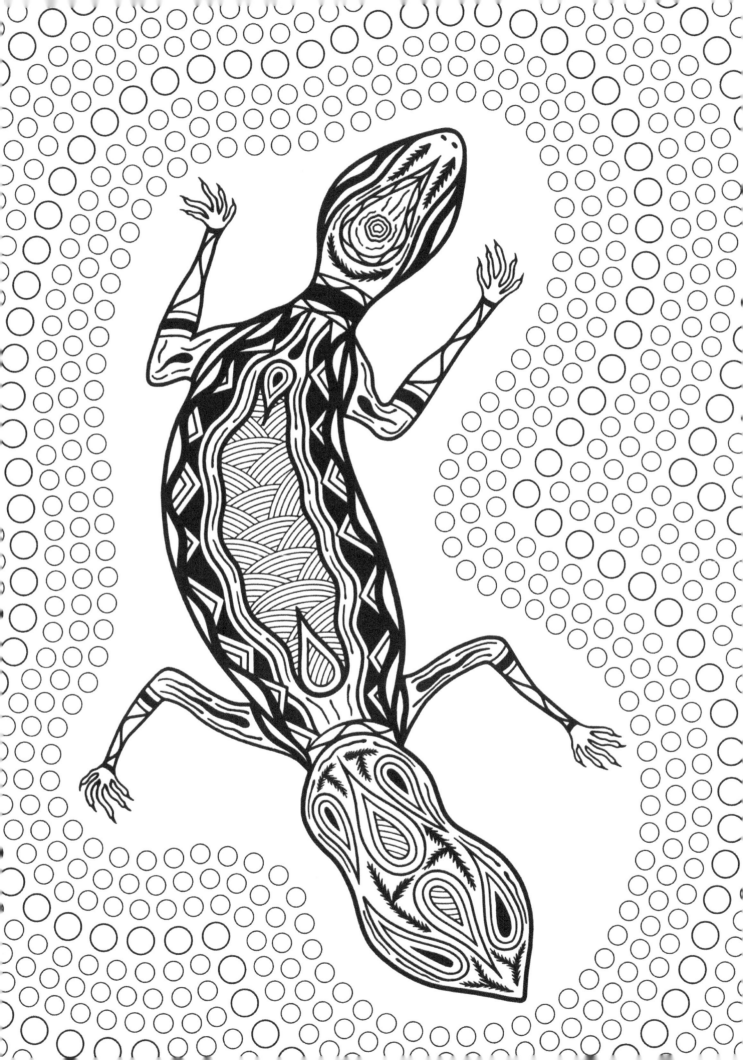

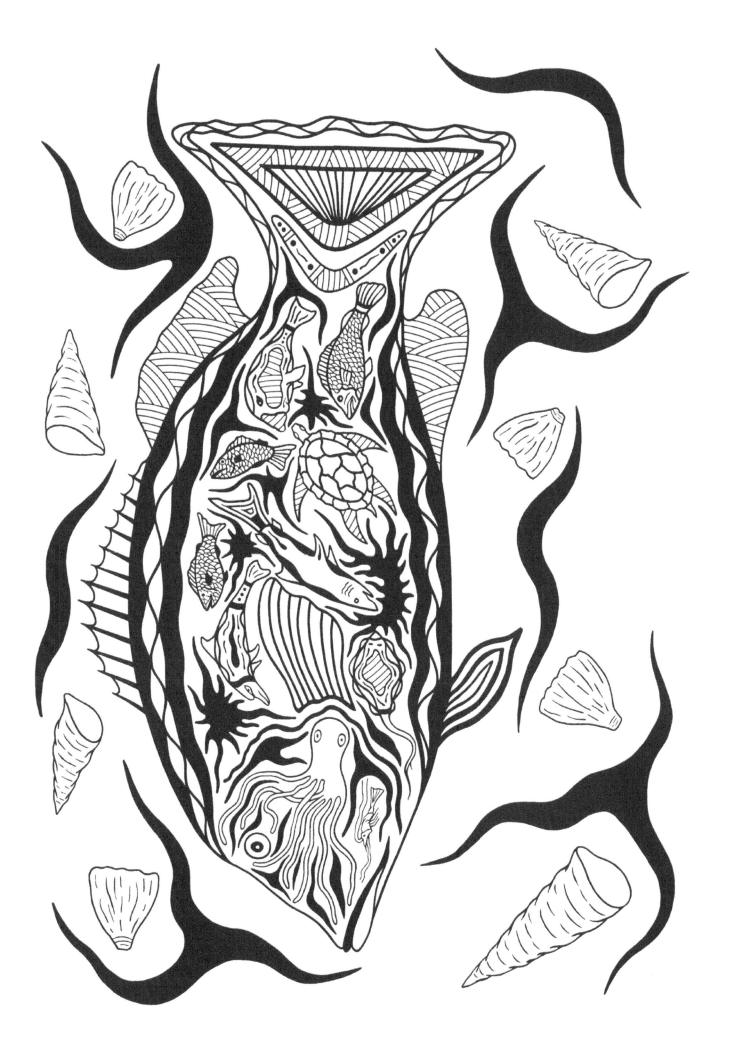

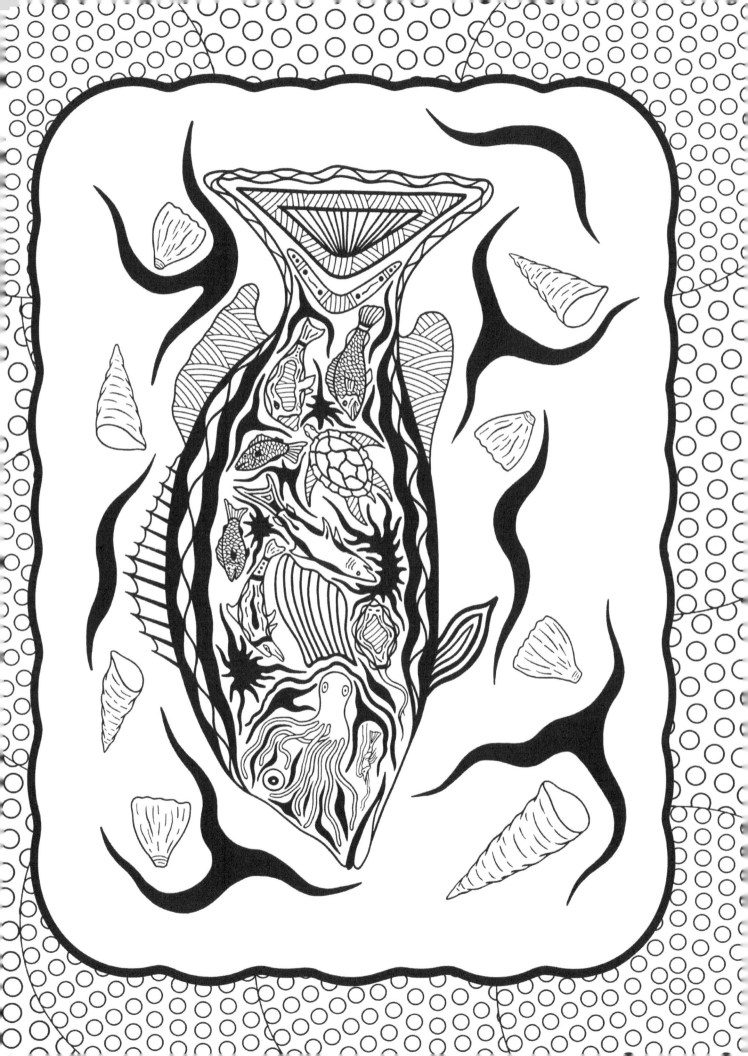

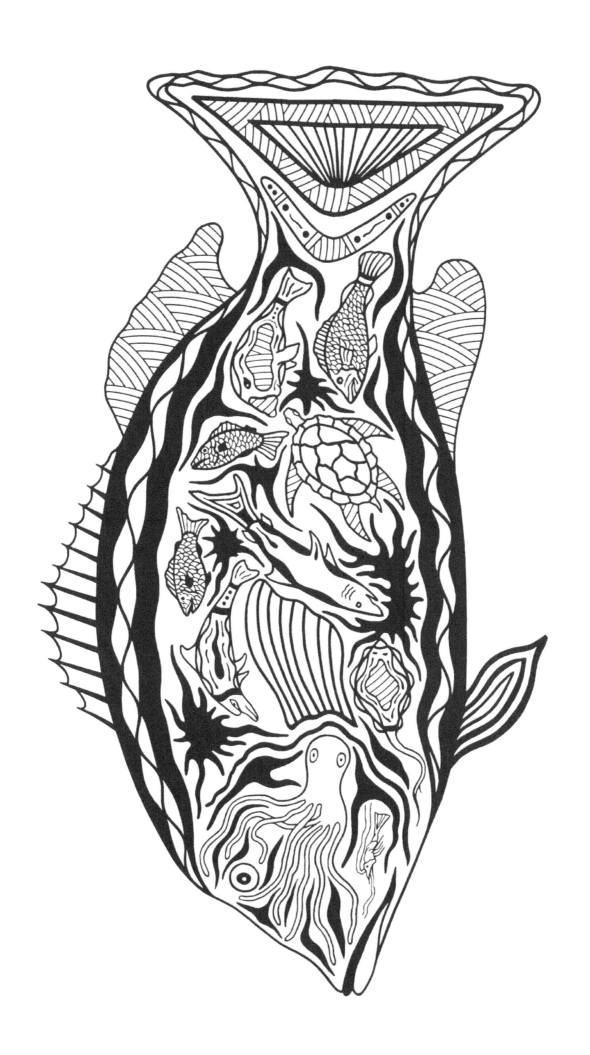

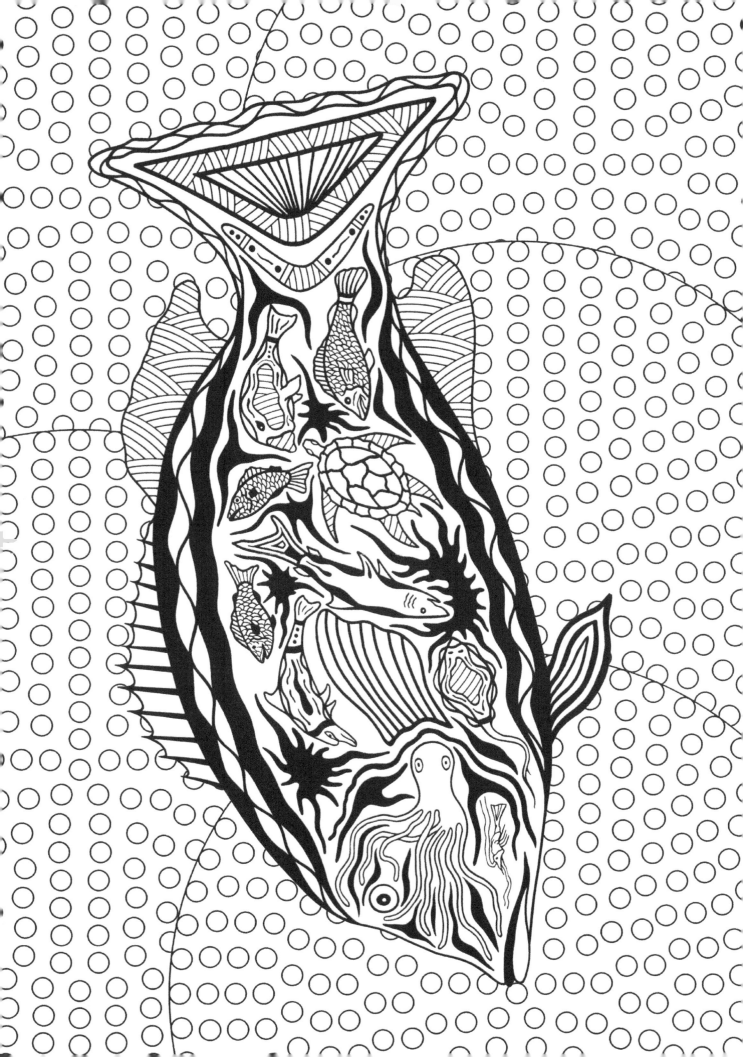

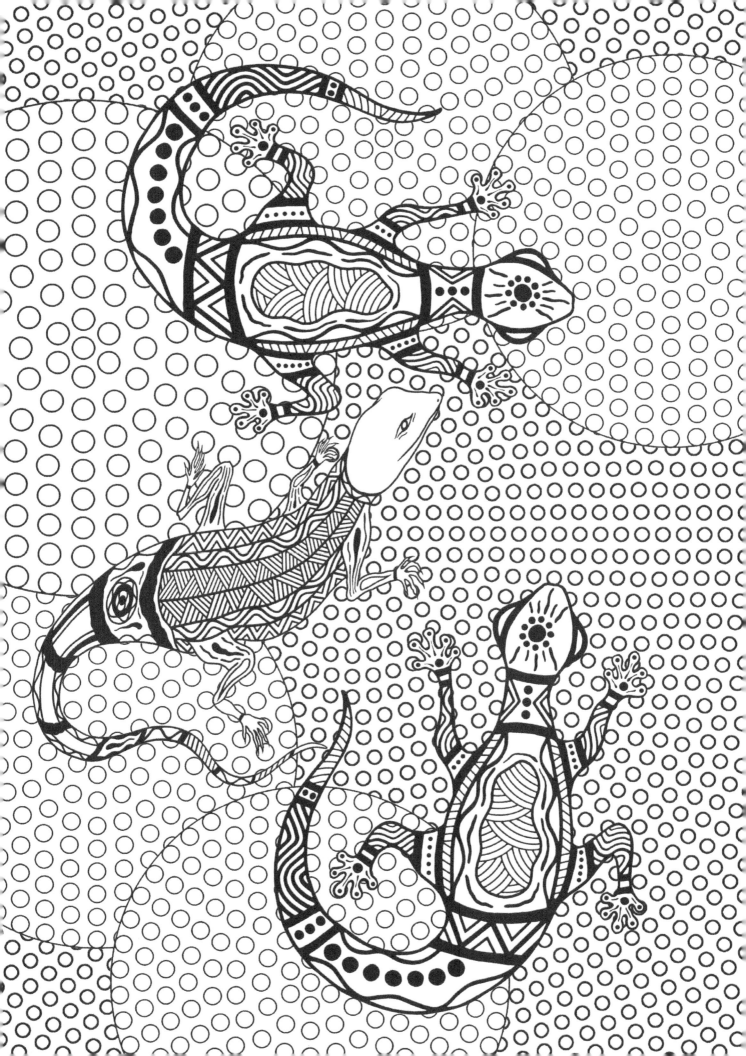

Bonus Page

Thank you for buying my book, you can download the PDF file of this book by sending me an email to dreamtimecolorart@gmail.com then I will send you the link for your download. Please write a review it would be greatly appreciated.

PS: Visit my Facebook page **www.facebook.com/dreamtimecolorart**

Have Fun,

Peter Platt.

Made in the USA
Coppell, TX
05 July 2022